FRENCH IMPRESSIONISTS

DRAWINGS OF THE MASTERS
FRENCH IMPRESSIONISTS

A selection of Drawings of the French 19th Century.

Selected and edited by Ira Moskowitz,

with a Text by Maurice Sérullaz,

Conservateur du Cabinet Edmond de Rothschild,

Louvre, Paris.

LITTLE, BROWN AND COMPANY BOSTON · TORONTO

A

LIBRARY OF CONGRESS CATALOGING IN PUBLICATION DATA

Moskowitz, Ira, ed.
 French impressionists.

 Reprint of the ed. published by Shorewood Publishers,
New York, in the series: Drawings of the masters.
 Bibliography: p.
 1. Drawings, French. 2. Impressionism (Art)—
France. I. Sérullaz, Maurice. II. Title. III. Series.
[NC246.M67 1975] 741.9′44 75–11514
ISBN 0–316–58560–2

Published simultaneously in Canada
by Little, Brown & Company (Canada) Limited

PRINTED IN THE UNITED STATES OF AMERICA

Contents

Foreword

French Impressionists is one of a series of books which form a treasury chosen from the vast store of the world's great drawings of all schools and periods, from the cave drawings of 30,000 B.C. to the present. An informative text by an eminent scholar in his specific field accompanies each volume.

These books are created for those already cognizant, and for lovers of art whose interest is increasing, with a rising appreciation of the values of drawing. Drawings are revelations of the freshest stage of artistic creation and spontaneous expressions of the artist's call to create.

Paintings are easily accessible to anyone within reach of the galleries and museums where they hang. Drawings, because they are fragile and subject to fading, are normally protected in portfolios and solander cases in special study or storage rooms, available mostly to scholars, advanced students, and collectors. For those who cannot take the extra time to obtain entry to drawing-cabinets, the next best thing is excellent reproductions.

These drawings were selected from hundreds of thousands of examples in drawing-cabinets of print rooms and major private collections all over the world. To serve historical as well as educational ends, our choice was guided by the intrinsic value and content of each individual drawing reproduced in this volume.

THE EDITOR

EDGAR DEGAS · *Studies of Ballet Dancers* · Black and white chalk · New York, The Brooklyn Museum

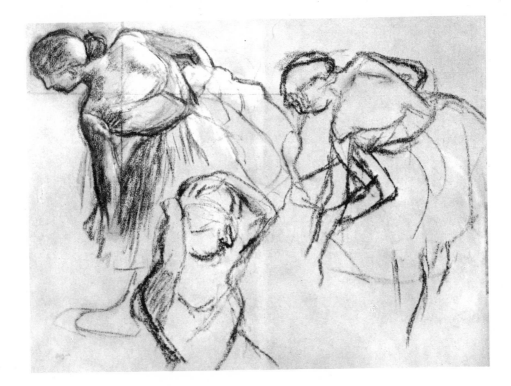

EDGAR DEGAS once explained to Paul Valéry what he meant by drawing: "Drawing is not form, it is the way of seeing form." Degas defined his own concept in terms that suggest the remarkable diversity of trends and styles implicit in the single word *drawing*. Drawing is the artist's most direct and spontaneous expression, a species of writing; it reveals, better than does painting, his true personality—a study of even the swiftest sketch discloses the mind and nature of its author.

For drawing, nineteenth-century France without question offered abundant creative possibilities. Mannerism, Classicism, and the Baroque—the heritage of the past—transposed and revitalized, blended in a vast melting-pot with the latest innovations to produce Romanticism, Realism, Impressionism, Symbolism. Yet beneath their amazing variety we can trace an internal unity

which characterizes the prodigious flowering of all French art during the nineteenth century. This common bond, this conductive link, is essentially the objective exploration of life. Even those artists who seem to stand apart are actually dedicated observers of reality, a reality captured in its instantaneousness. "One must be able to draw a man falling from the sixth floor," said Delacroix.

After David and Ingres the themes changed; from then on it became more the exception than the rule to find subjects inspired by Greece and Rome. The Romantics turned instead to the Middle Ages and to the Renaissance—but, far from restricting themselves to the past, they also discovered the nineteenth-century present.

No period since the Revolution of 1789 had offered such stimulus to French painters and draughtsmen. It was a time of conflict and of the growth of the daily newspaper; of interest in the Orient—its manners, customs, and landscapes; of new return to nature, but a nature thought of as vibrant, unconventional, vital. A time, above all, of concentration on man in his absolute individuality, with his passions, loneliness, dreams, enthusiasms—man conceived of as unique in his personality and manifold in his entity.

Then appeared the "modernity" that Baudelaire defined as "...the transitory, fleeting, contingent half of art; the other half is the eternal and immutable." The artist began to become aware of the central fact that his originality lies in what is individual and nontransferable in his message—on which principle modern art is founded. ("Romanticism," Baudelaire also wrote, "lies not merely in choice of subjects or in exact truth, but in the way of feeling.")

Eugène Delacroix transformed the art of drawing early in the century. His audacious reforms made possible the bursting forth of genuinely original work that went beyond traditional concepts to revolutionize the art of drawing and bring him to the threshold of Impressionism—a lineage recorded by the poet Jules Laforgue, who noted: "the ebullition of the Impressionists

with a thousand dancing spangles, the wonderful discovery anticipated by that madman of movement, Delacroix, who, in the cold furies of Romanticism, not content with violent movements and furious colors, models with vibrant hatch strokes."

But Delacroix had passed through successive stages to reach that point. Fertile in invention, daring in exploration and in accomplishment, fiery in emphasis, he practiced all the techniques of drawing—from graphite to charcoal, from pen to wash, from water color to pastel—because drawing was for him the means of enriching and disciplining his art. The unbridled lyricism of his early days he tempered with classicism after his journey in 1832 to Morocco and Algeria, from which he brought back many sketchbooks filled with the studies and excellent water colors that formed a detailed reportage of his trip.

Then, toward the end of his career, Delacroix jumbled his lines into a whirlwind of strokes, depicting at once the passionate life of his models and the dynamism of their embodiment in space; the most superb suggestions of movement in the history of drawing surged forth. The pulsation of life is in his landscapes. Considered the leader of the Romantic School while priding himself on being a pure classicist, Delacroix paved the way for the Impressionists through this fascination for evanescent motion. Baudelaire could indeed write that he rendered "...perfectly the movement, the visage, the illusive and flickering aspect of nature." Precursor of the Impressionists in still another way, Delacroix delighted in the reflections of light, of which he was one of the first to show the importance (in his water colors, which displayed great freedom of style) with vivid colors applied in quivering strokes.

Pierre Lavallée well analyzed the drawings of Delacroix when he wrote: "A unique vitality, a romantic imagination, love of order and clarity, affinities with a past recent or distant, a modernity that will extend into the future are affirmed in the complex trends of his drawing, which seems...a keystone in the gateway between the old art and modern art."

In Barye, another Romanticist, the draughtsman is the equal of the sculptor; his water colors in particular make a prodigious catalogue of animal life.

The Realists, offspring of the Revolution of 1848, pushed farther ahead in this thirst for actuality found among the Romantics. As early as 1830, the industrial revolution brought an upheaval of society. The positivist philosophy of Auguste Comte marked the decisive turning point. Artists abandoned completely the esthetics of the *beau idéal* for those of contemporary life and modernism. "The naked truth is art," announced the critic Champfleury. The press, on its side, was to prove a highly potent force; it answered the double necessity of acting quickly and of influencing the greatest possible audience. Its sole theme was to be the present, caricature its great weapon. We thus witness the birth of a new genre in art, one that would demand new plastic methods. Baudelaire wrote: "There is in ordinary life, in the daily metamorphosis of external things, a rapid movement that demands an equal speed of execution on the part of the artist." This process of rapid execution was lithography, developed in 1796 by Aloïs Senefelder. After 1830, its use spread tremendously. The requirement that the artist see quickly, create quickly, and give his drawing to the newspaper every day produced a new discipline.

Daumier was trained in this discipline; because of this his drawing acquired its acuteness, its power of synthesis—and the drawings are unquestionably the most interesting part of his work. It should be noted that this realist almost never drew from nature. Endowed with an unusual visual memory, he retained in his mind an exact picture of everything he observed during the day and then captured it on paper or on the lithograph stone. Excited by form, he sought dimension first of all, and his drawings show the influence of two great sculptors of the past, Michelangelo and Puget.

Reverting several times to certain themes, Daumier was able to maintain freshness through the multiplicity of his techniques. He used pencil and pen in turn, often heightened with wash or water color—not with a colorist's care

but to accentuate reality. Around 1853 Daumier discovered the artistic importance of light waves and at times shows himself the precursor of Cézanne's impressionism. Leaving *Le Charivari* about 1858, he was inspired more and more by daily life, by street scenes, but without ever descending to anecdote. Traveling shows, literature—Molière, La Fontaine, and (particularly) Cervantes and his *Don Quixote*—inspired his brilliant works, at once satirical and immediate. A deeply sensitive interpreter of human passions, Daumier is the peer of the greatest. "M. Daumier draws perhaps better than Delacroix," noted Baudelaire, "if one prefers sane and healthy qualities to the strange and amazing gifts of a great genius sick with genius."

Leader of the Realist School, Courbet sought to place his art at the service of society, thus joining his friend the socialist writer Proudhon. A painter primarily, this master drew little and his drawings, the result of laborious effort, are generally heavy in style; their strength and sense of realism make them, however, a mode of expression rather peculiar to their creator.

Today we generally consider Millet the draughtsman much superior to Millet the painter. This Realist, associated with the Barbizon School, sometimes reveals pre-Impressionist tendencies and puts into his pencil studies what he could not express in his paintings, which are often too literary. His bare and unemphasized line attains a poetry of striking starkness; his sketches, always spontaneous, reveal a profound understanding of country life and do not stop at mere description. In a landscape, he first saw (he said) only two things, the sky and the earth. "I build upon that; all the rest is only accidental and episodic." The diversity of techniques he used produced a diversity of styles, the novelty of which was to influence a number of his successors—van Gogh, Pissarro, and Seurat in particular.

Although Millet belonged to the Barbizon School, it is such landscapists as Théodore Rousseau or Daubigny who are most representative. The often synthetic style of Rousseau does not abhor naturalist details, which are rendered with perfect accuracy, while Daubigny, who worked not only at Barbi-

zon in the Forest of Fontainebleau but also on the banks of the Oise or on the Norman coast—before Impressionism—liked to capture reflections on water.

Corot noted in one of his sketchbooks, "Draw every evening." This constant preoccupation led him to leave many drawings, the style of which never stopped evolving from the beginning to the end of his career. Until about 1850 he used pencil almost exclusively and the purity of his graphic sense, which sometimes brings to mind certain Primitives—especially in the portraits and in his Italian landscapes—reveals an acute sensitivity coupled with a precise awareness of form. Changing his goal, Corot changed his technique; his interest now lay in the poetic evocation of a site. He focused only on the planes and general masses of a landscape enveloped by misty atmosphere. Melancholic reverie was accentuated after 1860, when the problem of reflections, the fleeting and evanescent aspect of things, haunted him. He then deliberately used charcoal, with which he obtained deep velvety blacks, and stump, which enabled him to get vaporous effects. The path he blazed was thus soon to lead artists to Impressionism; it is difficult not to see a direct predecessor in one who said: "Beauty in art is truth bathed in the impression we have received by seeing nature."

Thus, with Romanticism and, more, Realism, there began that feverish search for truth, for reality, that the following generation would advance to the utmost, to the realm of pure sensation. "All knowledge that is not preceded by sensation is useless to me," wrote André Gide in *Fruits of the Earth*. This justification of sensation is fundamental in Impressionism. A new way of seeing was now accompanied by a new way of painting and drawing. The outline drawing delineating form and suggesting volume was banished; it was generally replaced by very free drawing with tangled and sometimes vague lines giving the illusion of mobility and by planes of light and shadow producing an effect of mass. Water color and crayon were often used, for both these media made it possible to evoke light and its reflections and, more important, to put into play relations of colors both vivid and subtle. Per-

JEAN-BAPTISTE COROT · *The Forest of Coubron* · Charcoal · Cambridge, Mass., Fogg Art Museum

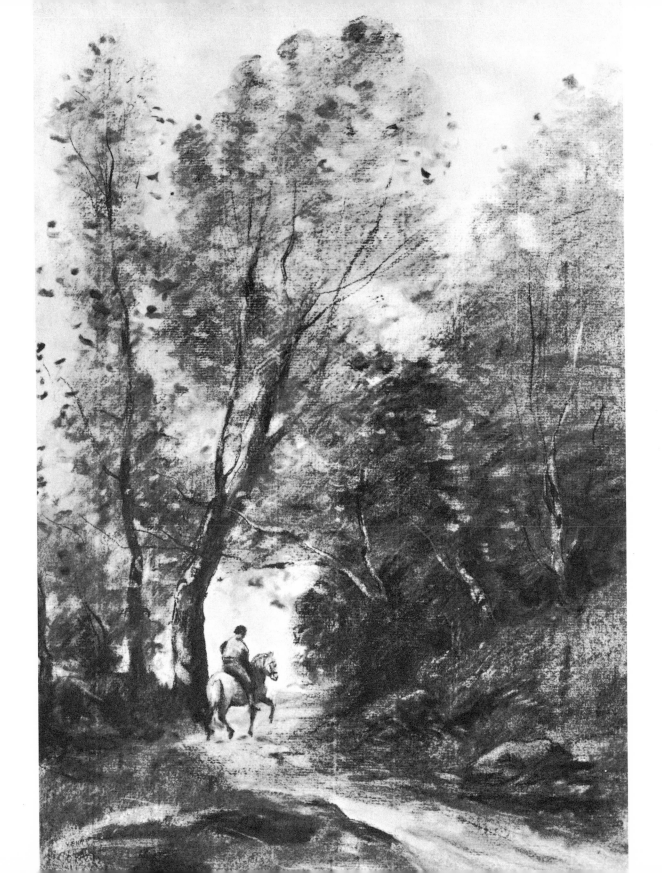

spective was then no longer based on rules of geometry, but was achieved, from foreground to horizon, by the gradation of tints and tones, suggesting space and volume. Tint, as Signac pointed out, is the quality of a color (for example, for blues ultramarine, cobalt, cerulean, Prussian, etc.), and tone is the degree of intensity of a tint, from darkest to lightest, each tint then passing through a series of tones. Everything thus became shaded, even shadows—which are always colored by reflections. Everything moved, everything vibrated, everything changed and was transformed from one instant to the next. Photography, a recently created technique in which some sought art, attempted to fix the image of this evanescence. It revealed to artists unknown aspects of the world: new angles, close-ups, arresting of movement, snapshots with which painters and draughtsmen tried to compete, too, by capturing the fleeting moment. But though of practical aid, the new invention soon became a rival. "It compels one to cease trying to describe what can be recorded by itself," asserted Valéry.

Another element exerted a marked influence on the young artists—the vogue of Japan and its art. *Japonisme* was honored. Some draughtsmen of the Impressionist period were seduced by the original make-up of off-center and often oblique composition; others adapted particularly the schematization of forms expressed in simplified lines; some were attracted by misty effects and the evanescence of the atmosphere.

Already painting outdoors, such pre-Impressionist artists as Boudin, Jongkind, and Bazille laid the essential foundations of the new art. The first two, who belonged to the Saint-Siméon School in Normandy, were—through an acute perception of the multiplicity and continuity of light waves—for the first time in the history of art to give nature an image which would lose nothing of its ceaseless mobility in transposition: Boudin in his pastels of skies and in his water colors of beaches, and Jongkind in his many water colors in which light fluid touches "swept" the paper to suggest the most fugitive of rays. Bazille, who belonged to the Provence School, devoted himself

to the problem of light intensity and strong contrasts of light and shadow in drawings that were nevertheless realistic.

Also a Realist, more independent than Impressionist, was Edouard Manet, who left only a limited number of drawings: pure-line studies of nudes; wash drawings or forceful sketches nimbly drawn with broad India-ink blacks, the terseness of which reminds one of the Japanese; crayon portraits in harmonies of gray, pink, and black directly traceable to the art of Goya.

A classic painter of modern life—as he defined himself—Degas was one of the greatest draughtsmen of the nineteenth century. In contrast to his Impressionist friends, who generally did little drawing, he found in this field his most perfect means of expression. "I was born above all to draw," he once said. Influenced at first in his portraits and historical compositions by the great classic tradition of the Renaissance Italians and of Ingres, he gradually liberated himself and, while retaining a discipline founded on the harmony of rhythms, he tended to reconstruct forms by constantly reconsidering them from a new angle. Using certain themes—modistes, race-course scenes, laundresses, dancers, women at the dressing table—he studied every possibility ceaselessly from a new vantage and, analyzing their mysterious geometry, untiringly sought to crystallize movement. His originality also lay in imagining his subject in a bold off-center composition which he owed undoubtedly to the Japanese influence.

In the second half of his career and as his eyesight weakened, Degas more willingly employed pastel applied in broad strokes and went beyond form to express its quintessence. He proved himself an exceptional colorist and his tints—singular and subtle with sometimes daring contrasts—directly opened the way to the Nabis, especially Bonnard.

Paul Valéry admirably summed up the direction of this plastic search: "A passionate desire for the single line determining a face, but that face drawn from life, from the street, at the Opéra, at the modiste . . . a face caught in its most special expression at a given instant, never without anima-

tion, always expressive—these by and large sum up Degas for me. He attempted and dared to combine the instantaneous impression and the infinite labor of the studio, to capture the impression in profound study, and the immediate in the lasting quality of thoughtful purpose."

The pure Impressionists were too enamored of light and color to like to draw very much, except for Pissarro and Renoir. From Claude Monet, the leader of the movement, only a few drawings are known, quick landscape sketches, souvenirs of a fleeting impression. That is also the case with Sisley, more sensitive in the delicate sketches in which he was able to evoke poetically the nuances of an atmosphere. As a draughtsman, the more constructive Pissarro employed varied techniques. Except for black pencil and charcoal, with which he limned sturdy peasants, his Impressionism sought color. He also used water color, gouache, which he applied in spot touches, or color pencil or pastel in vibrant hachures with vivid tonalities. For three years, from 1886 to 1888, he practiced divisionism and pointillism, following the examples of Seurat and Signac, then returned to his original conception.

The evolution of Renoir's drawing style parallels that of his painting style. During his Impressionist period he especially liked water color, sometimes washed and transparent, sometimes refined, like a Persian miniature, in dazzling colors. No longer limiting himself to the Impressionist concept alone, he then returned to drawing, studied the Italians and Ingres, and noted: "Toward 1883 there was a break in my work. I had reached the end of Impressionism and came to the realization that I knew how neither to paint nor to draw. . . ." He also drew pen portraits and, especially, nudes with an extremely clean and stylistic graphic sense. Then, toward the end of his career, under the influence of his friend the sculptor Maillol and in a pantheistic spirit, he continued to render portraits and nudes, but with a far more complex technique, in which the jumble of lines reveals the opulence and elasticity of forms and red chalk or red ochre crayon, soft charcoal and white chalk are blended, these materials sometimes watered and applied on a canvas with a brush—paint drawings!

PIERRE AUGUSTE RENOIR · *Nude Dressing* · Black chalk · New York, Charles E. Slatkin Gallery

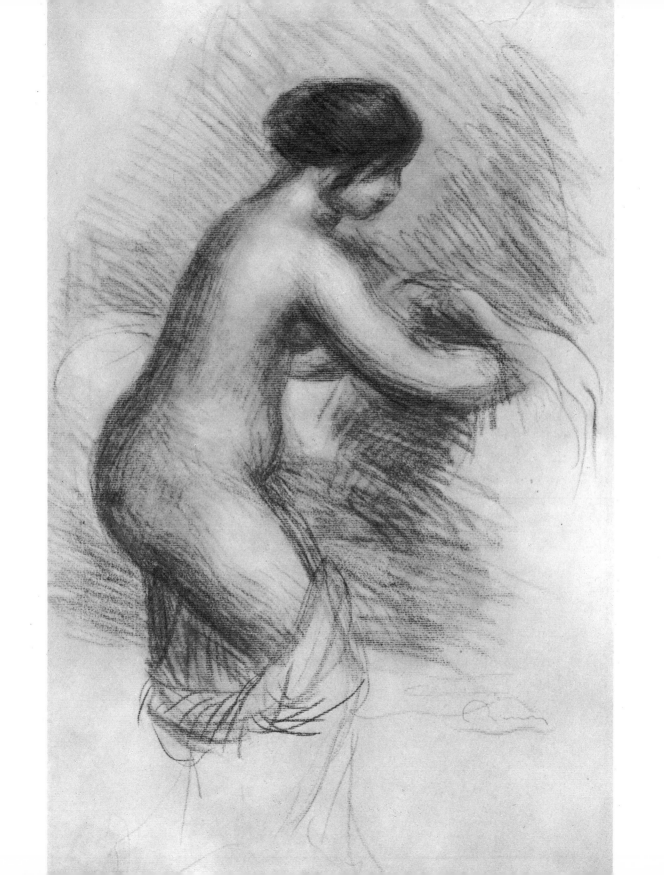

Two women were associated with the Impressionist group, the French-woman Berthe Morisot and the American Mary Cassatt. Both drew their subjects primarily from everyday life, and Valéry pointed out of Berthe Morisot: "Girl, wife, mother, her sketches and her pictures follow her life and accompany her very closely. I am tempted to say that all of her work suggests what the diary of a woman whose means of expression were color and drawing would be like."

The art of Cézanne, though still linked to sensation, is first of all well constructed and thought out; that is, he was in part opposed to the esthetics of the Impressionists and returned to form and, therefore, to a large extent to drawing. The artist quite soon abandoned his early pencil sketches (their rather sustained style is not without some gaucherie) for sparse studies with wide simple planes and powerfully geometrized forms. He heightened them with water color, color being for him an irreplaceable means of expression— he noted: "Drawing and color are not separate. In proportion as one paints, one draws. The more harmonious the color, the more the drawing takes shape. When color is at its richest, form is at its fullest; contrasts and tone gradations, that is the secret of drawing and richness of form."

Toward the end of his career he reconstructed "his" universe. "Art is harmony paralleling nature," he said in a lyrical fashion that nevertheless did not exclude the strict construction in which Cubism was to find its source.

Reacting against the informality of Impressionism, Seurat codified its essential principles with the scientifically established theory of contrasts. The leader of Neo-Impressionism first expressed himself only in intellectually balanced black and white. He was, moreover, to turn out some four hundred drawings during his brief career. "The most beautiful painter drawings there are," said his friend Signac. A very special method enabled Seurat to model forms in light or in shadow by gentle gradations from the most varied whites to the most velvet blacks, passing through the whole range of grays; abandoning outlines and going over with crayon in successive but not parallel

PAUL CEZANNE • *Self Portrait (detail)* • Black chalk • Basel Kunstmuseum

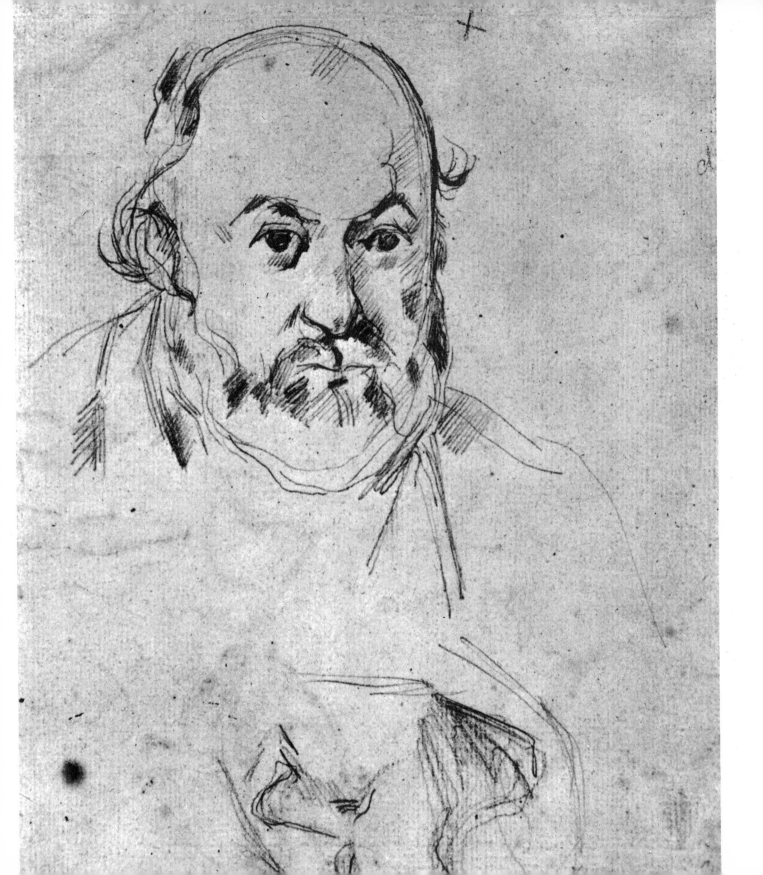

touches, he progressively intensified values to bring out volume and convey atmosphere. In spite of this absence of outlines and the apparent fuzziness of certain silhouettes, the construction is strict and his drawings are monumental.

Paul Signac devoted himself almost exclusively to landscapes, to which he applied Seurat's divisionist method; his water colors, with light, free treatment and delicate hues, are his best work.

The drawings of van Gogh followed the breathless rhythm of artistic sensitivity in constant tension. They reflect not only his stylistic search but also the desperate quest for an absolute in beauty that was to upset his mental balance. Van Gogh drew a great deal: in fewer than seven years more than nine hundred drawings and water colors. Through them one can follow the implacable course toward madness of this man from the North disturbed by the revelation of Mediterranean light. From his first highly realistic studies, executed under the influence of Millet and Mauve with an often rough, broken, and angular but always expressive graphic style, he passed, after the Impressionistic and japonistic experiments, to a vastly more schematic and original style. The reed pen became his preferred tool; it made possible a spontaneous, taut, highly varied stroke; hachures and dots are thrown on paper with an ever-growing ardor. A sort of dizziness seized him, and forms undulate and whirl in a tragic hallucination wherein the universe is dislodged. The radiance of van Gogh extended well beyond Impressionism and was the source of Fauvism and Expressionism.

"I have tried to do what is true and not ideal," declared Toulouse-Lautrec. His uncompromising thirst for the truth appears particularly in his drawings and illustrations in which, going beyond caricature and satire, the artist brings out his models at their most intimate. His themes were most often borrowed from the cabarets, music halls—from all places of pleasure. In his rapid sketches, employing highly varied techniques, Lautrec retranscribed movement in its spontaneity and caught not only the likeness, but even more

TOULOUSE-LAUTREC · *M. Desire Dihau playing the Bassoon* · Black chalk · New York, Mr. and Mrs. Edward M. M. Warburg

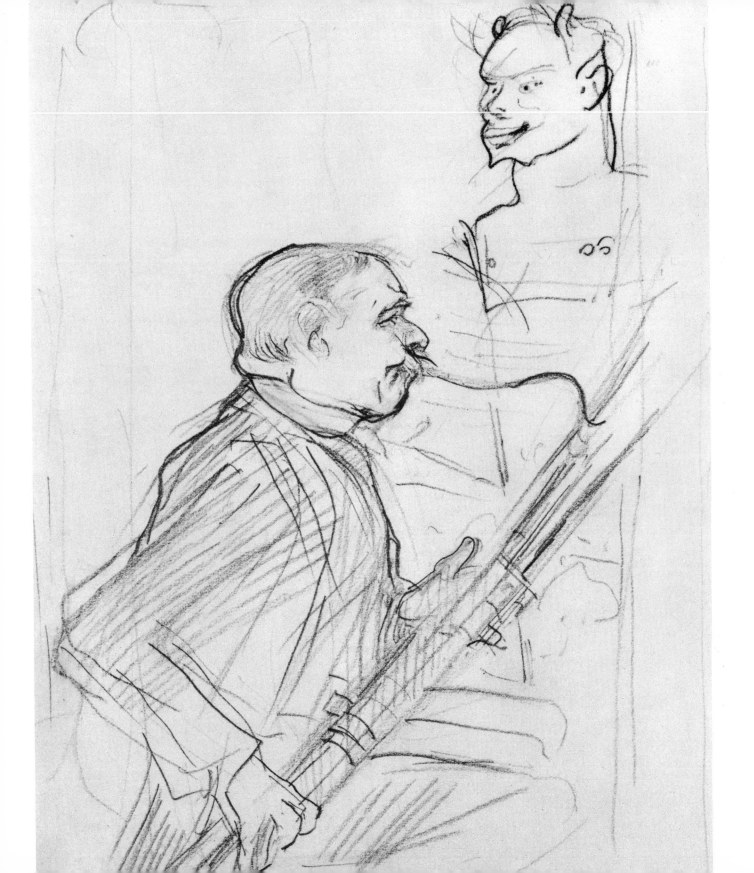

the character, scrupulously analyzing—without minutiae—the stance, the gesture, or the individual expression, seizing the salient feature, the mannerism that marks everyone indelibly. His highly schematic style, borrowed from the Japanese, stresses in a few keen and peremptory accents the identifying mark of a person and, in general, that of the mores of his time. His incisive art's harsh sincerity would sometimes shock, but it carried the message of a being who sought to penetrate the poignant secret of the human soul.

Forain drew a great deal, notably for newspapers—*Le Courier Français, Le Rire* among them. His biting and extraordinarily accurate stroke spiritedly caricatured the *Belle Epoque*.

Fantin-Latour displayed an intimate sensitivity in his portraits of artists of the period.

The drawings of sculptors sometimes surpass the drawings of painters, at least in power of form.

Rodin's drawings were exceptionally important to his plastic work. Well-thought-out forms come forth under his pencil or pen with an impetuous lyricism, while in the second half of his career he sought in water-color drawings boldness of rhythm and effects of movement of surprising originality.

While Bourdelle sometimes displayed in his drawings a certain romantic vein, Maillol employed a deeply personal language. The monumentality of his style and the fullness and plasticity of his line make him a great creator of forms.

Abandoning sensation for idea, the Symbolists were to give up the Impressionistic view for intellectual speculation. In an important article published in 1891 in *Mercure de France,* Georges-Albert Aurier wrote:

A work of art must be:
> 1. *Ideistic* [Idéiste], since its single ideal will be expression of the idea

2. *Symbolistic,* since it will express that idea in forms

3. *Synthetistic,* since it will present these forms, these symbols, in a way that is generally understood

4. *Subjective,* since the object will never be considered as object but as a sign of the idea perceived through the subject

5. (As a result) *Decorative,* for decorative painting proper, as conceived by the Egyptians and very probably by the Greeks and primitives, is no more than a manifestation of art that is subjective, synthetic, symbolistic and ideistic at the same time.

Confronted by external reality, the only thing in which the Impressionists were interested, Odilon Redon asserted interior reality. Redon gave the title "Blacks" to all the five or six hundred charcoal drawings and many lithographs he executed until 1890. In charcoal he found perhaps his best means of expression; it facilitated, he said, his "search for chiaroscuro and the invisible." After 1900 he no longer used this medium, but turned out with black pencil, red chalk, and India-ink wash many studies for his compositions and also striking water colors. But it was particularly in pastel that he made the transition from the black work to the colored. The work of this visionary artist, who sought to place "the logic of the visible at the service of the invisible," is imprinted with a mysterious poetry and directly heralds Surrealism.

In his drawings Gauguin untiringly pursued the search for "his" truth. Nothing spontaneous in him; everything is channeled toward that "primitive art" he aspired to re-create. It was in Brittany, at Pont-Aven, that Cloisonism and Synthetism were born in 1888. A spontaneous stroke encircles archaic forms and contains the color—water color or pencil—applied in flat tints. These features are further revealed in his Tahitian period, but in his water colors the tints become livelier, more luxuriant, and his eminently decorative style opened the way to much of contemporary art, to Cubism, and to Fauvism.

This quick survey enables us to sense the importance of drawing in the artistic life of nineteenth-century France; few were the painters who did not discover in it, aside from a means of study, an esthetic pleasure capable of making drawing an art equal to painting, sculpture, or engraving. It is this new aspect our contemporaries will develop by enriching it and giving it widespread application.

MAURICE SÉRULLAZ
Conservateur du Cabinet Edmond de Rothschild,
Musée du Louvre

PLATES

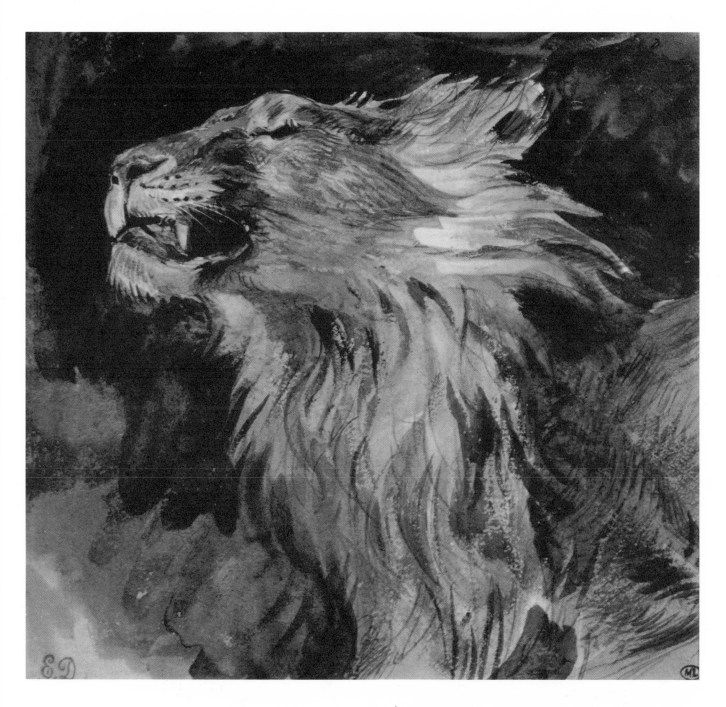

EUGÈNE DELACROIX · *Head of a Lion* · Water color · Paris, Louvre

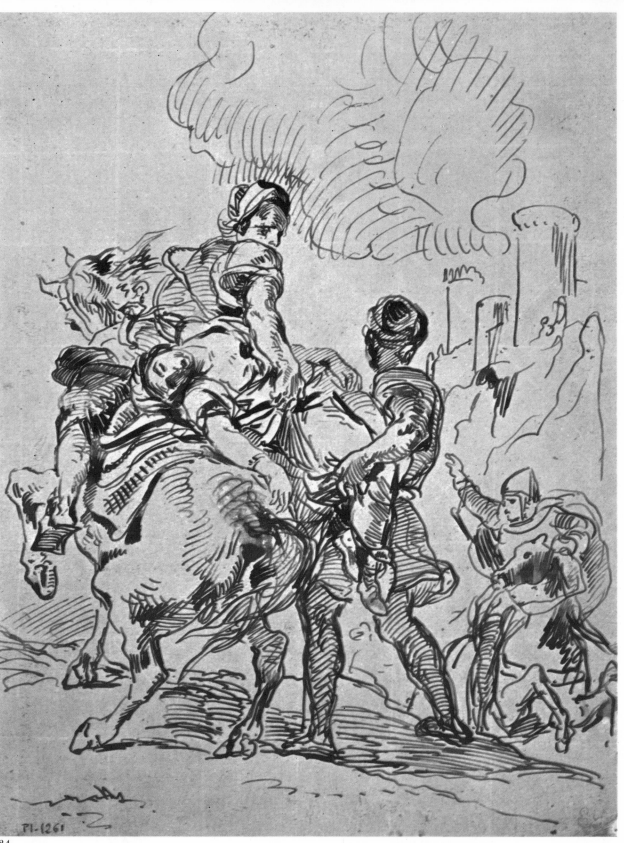

34

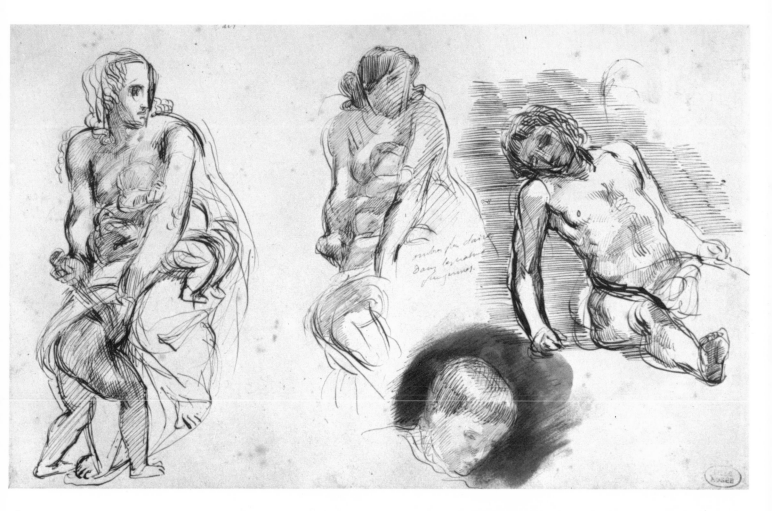

EUGÈNE DELACROIX • *Studies for "Medea"* • Pen and brown ink • Lille, Palais des Beaux-Arts, Musée Wicar

EUGÈNE DELACROIX • *Study for "The Abduction of Rebecca"* • Pen and brown ink • Lille, Palais des Beaux-Arts, Musée Wicar

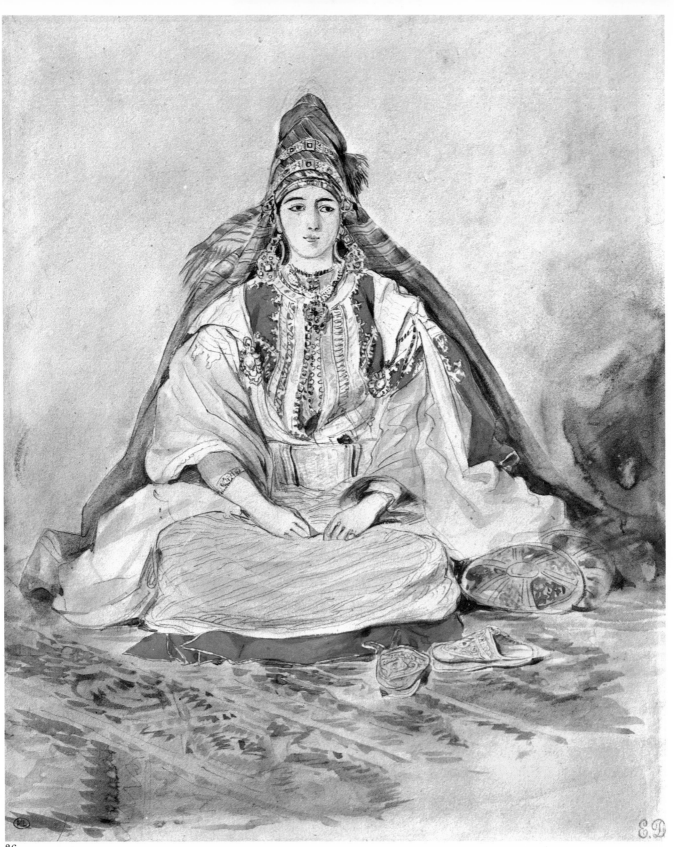

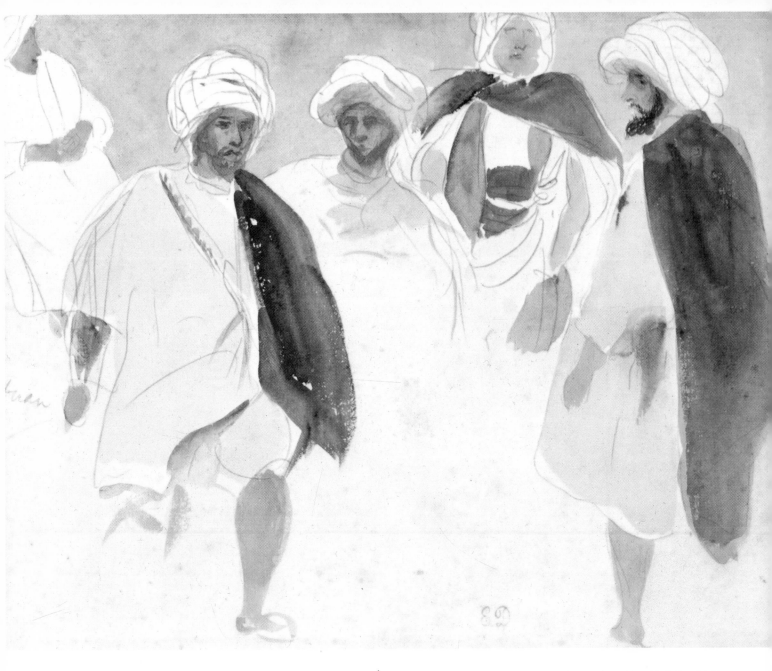

EUGÈNE DELACROIX · *Arabs of Tetuan* · Water color · New York, Leo M. Rogers

EUGÈNE DELACROIX · *The Jewish Bride* · Water color over pencil · Paris, Louvre

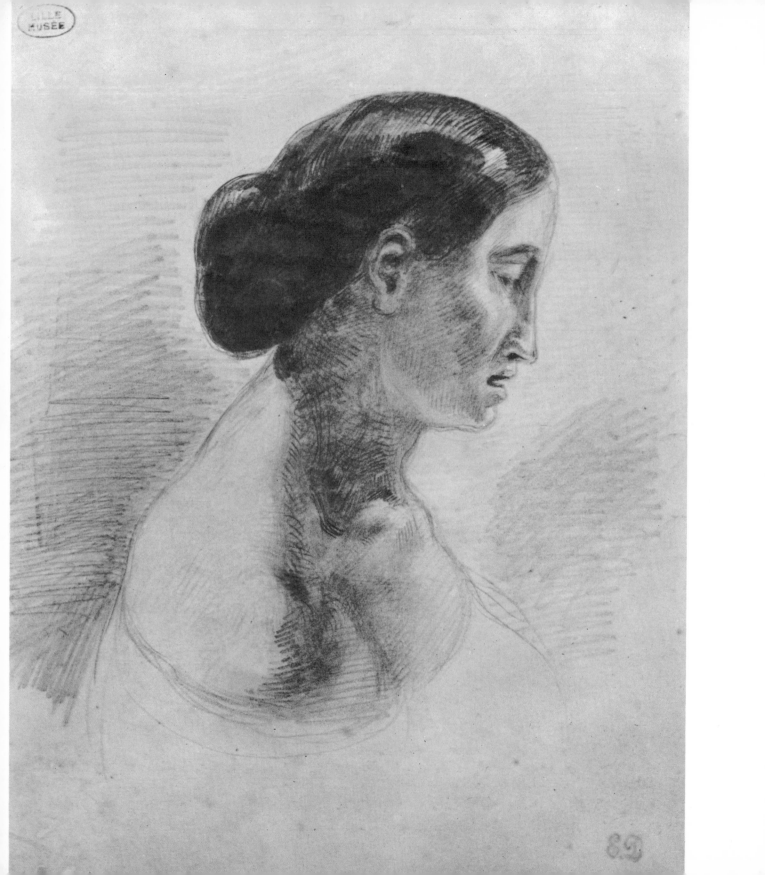

EUGÈNE DELACROIX
The Constable of Bourbon
Pursued by His Conscience
Brush wash in sepia over
black chalk
Basel, Kupferstichkabinett

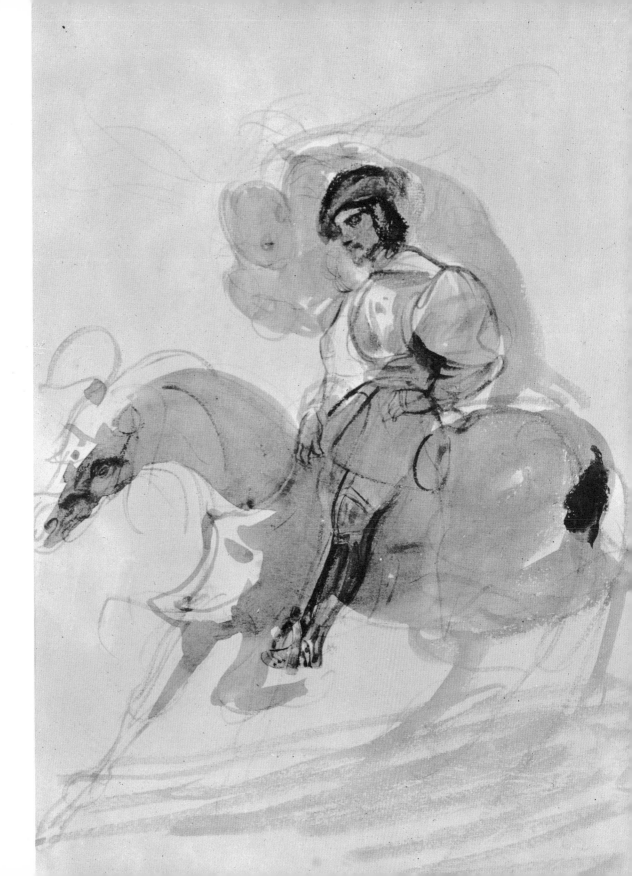

EUGÈNE DELACROIX
Lady in Profile to Right
Chalk and ink
Lille, Palais des Beaux-
Arts, Musée Wicar

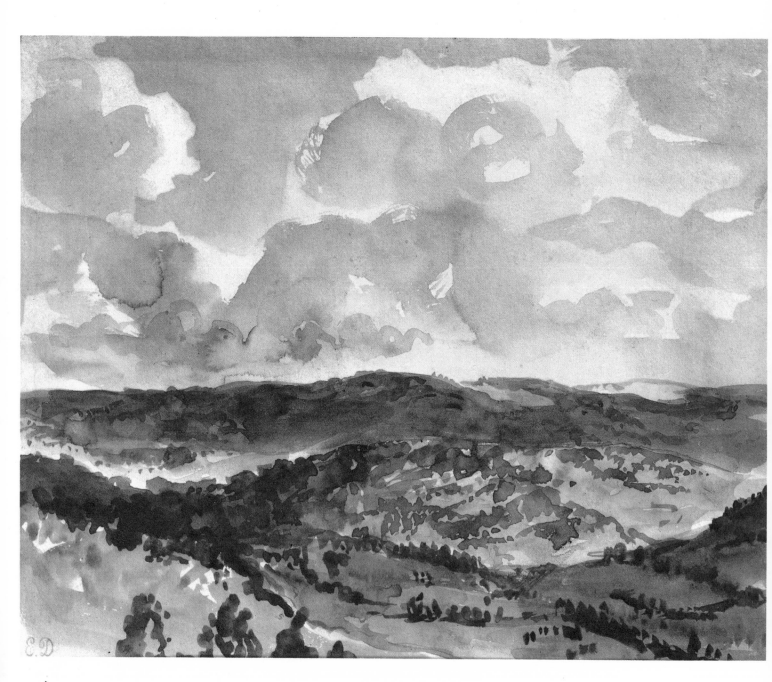

EUGÈNE DELACROIX · *Slope of a Hill* · Water color and gouache on brown paper · Paris, Louvre

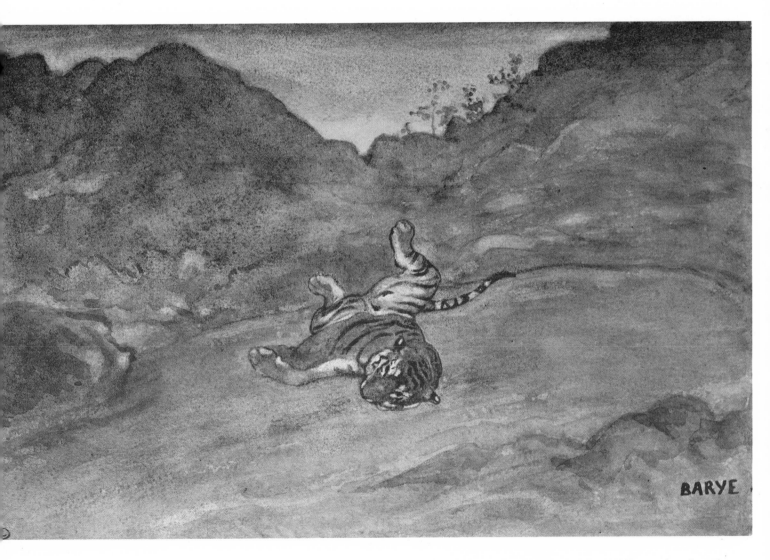

ANTOINE-LOUIS BARYE · *The Tiger* · Water color · Paris, Louvre

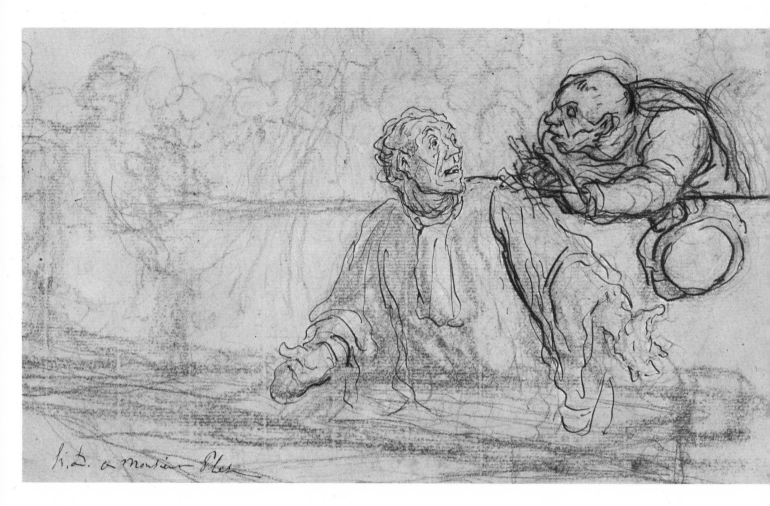

HONORÉ DAUMIER • *A Criminal Case* • Pen and black ink over pencil • London, Victoria and Albert

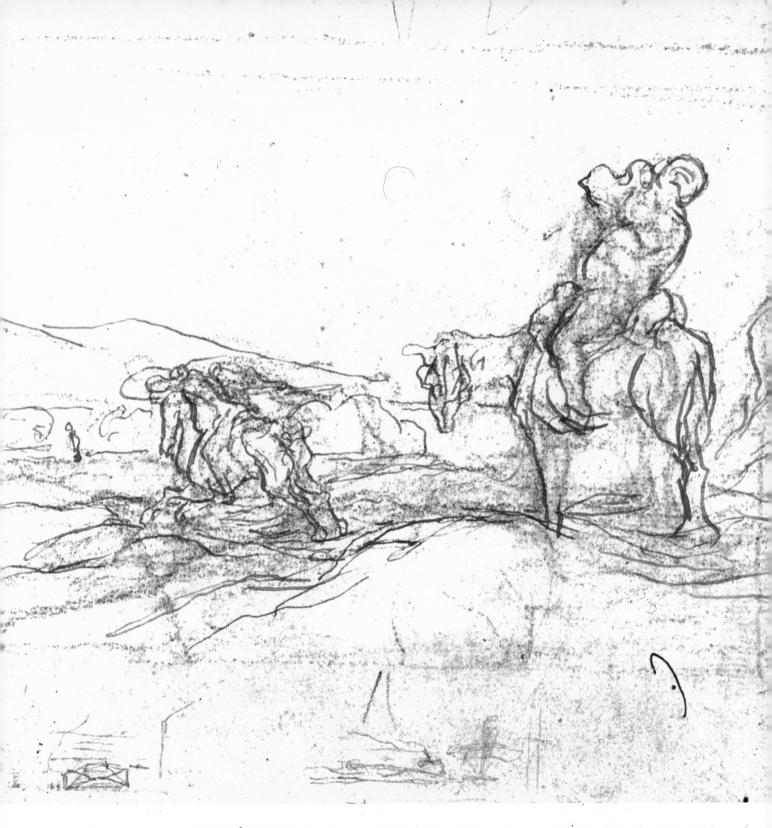

HONORÉ DAUMIER · *Don Quixote and Sancho Panza* · Pen and ink over charcoal · Paris, Claude Roger-Marx

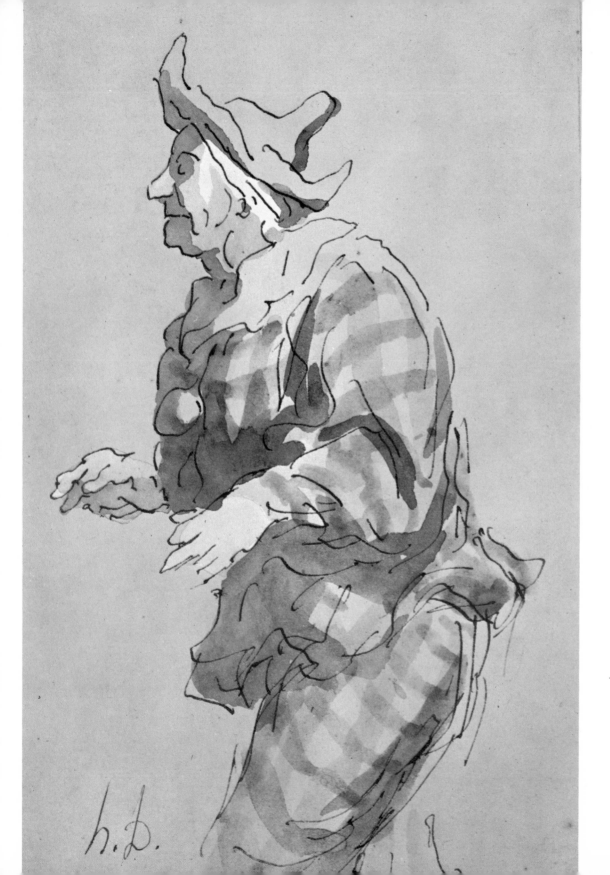

HONORÉ DAUMIER
The Clown
Black chalk
Paris, Claude Roger-Marx

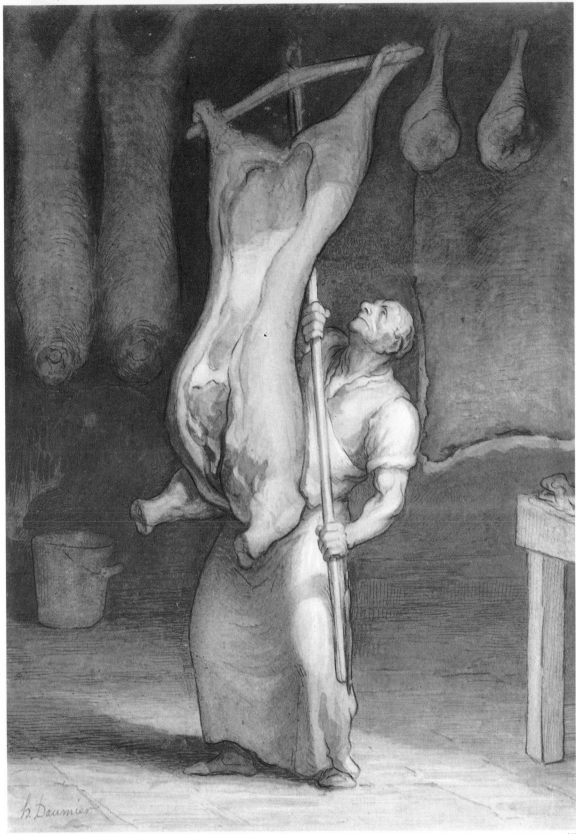

HONORÉ DAUMIER
The Butcher
Charcoal, pen and black ink,
and water color
Cambridge, Mass.
Fogg Art Museum

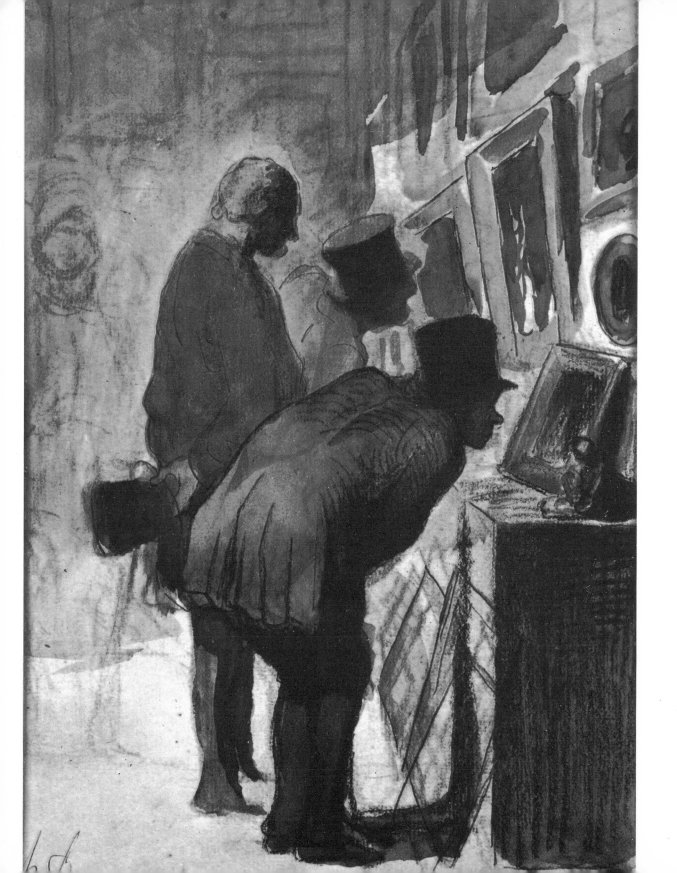

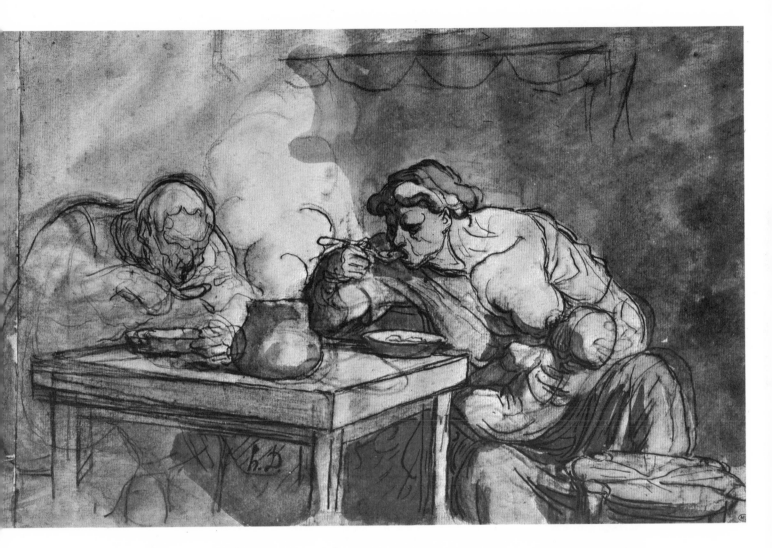

HONORÉ DAUMIER · *La Soupe* · Pen and India-ink wash, water color over traces of black chalk · Paris, Louvre

HONORÉ DAUMIER · *The Connoisseurs* · Pencil, charcoal, and water color · The Cleveland Museum of Art

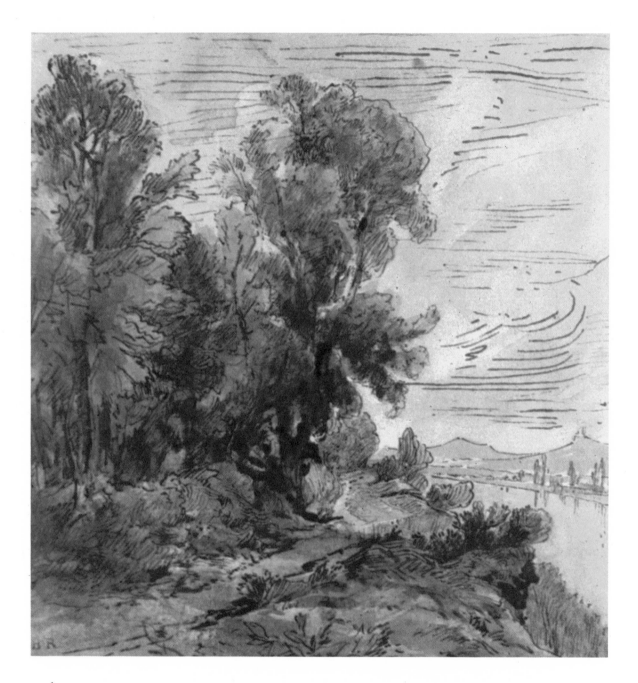

THÉODORE ROUSSEAU · *River Landscape* · Pen and water color · Budapest, Museum of Fine Arts

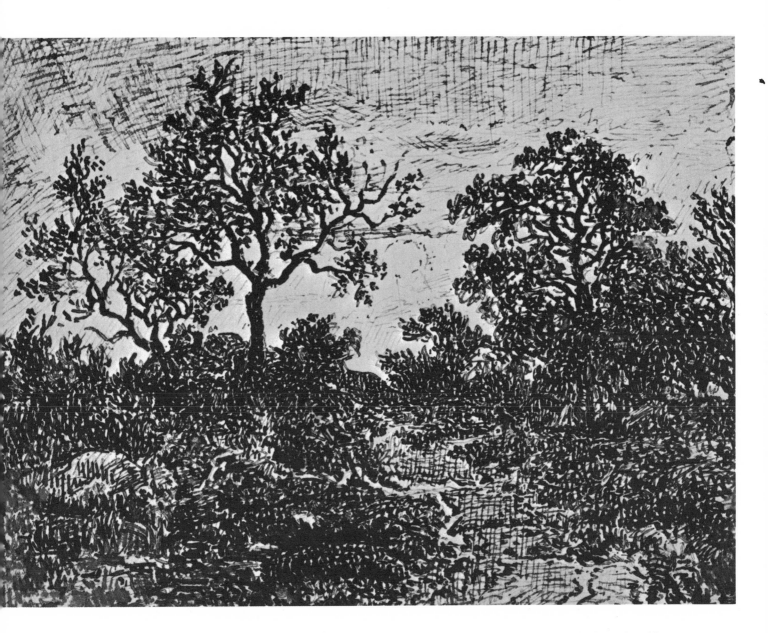

THÉODORE ROUSSEAU · *Landscape with Farmers' Huts* · Pen and brown ink · Rotterdam, Museum Boymans

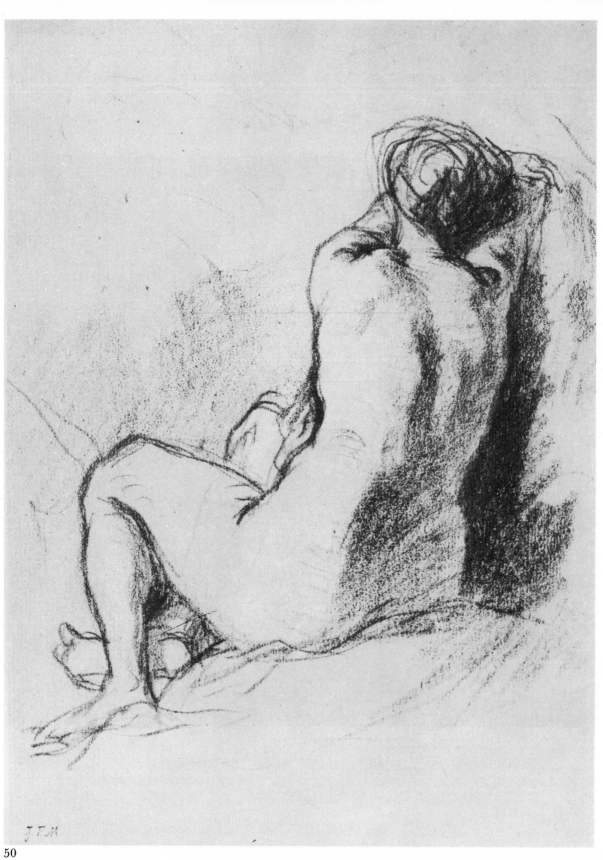

50

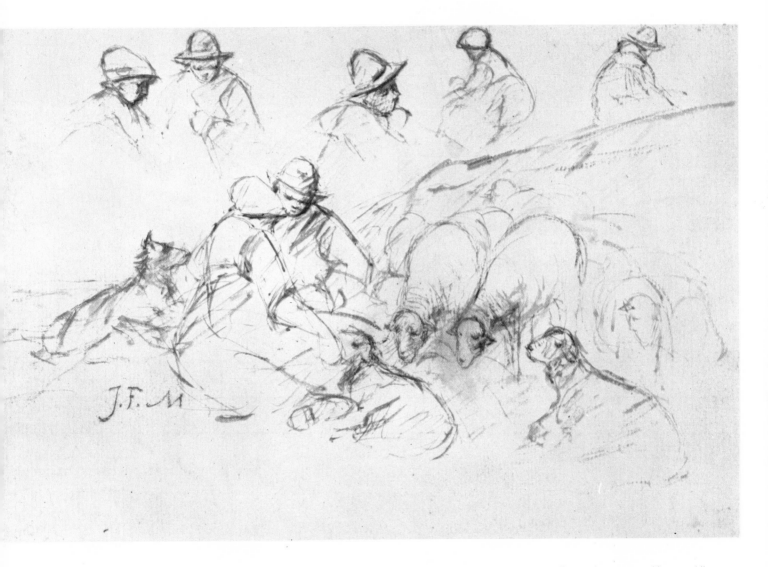

JEAN-FRANÇOIS MILLET • *Sketch of Shepherds and Sheep* • Red chalk on white paper • Vienna, Albertina

JEAN FRANÇOIS MILLET • *Nude Figure* • Black Crayon • Chicago, The Art Institute

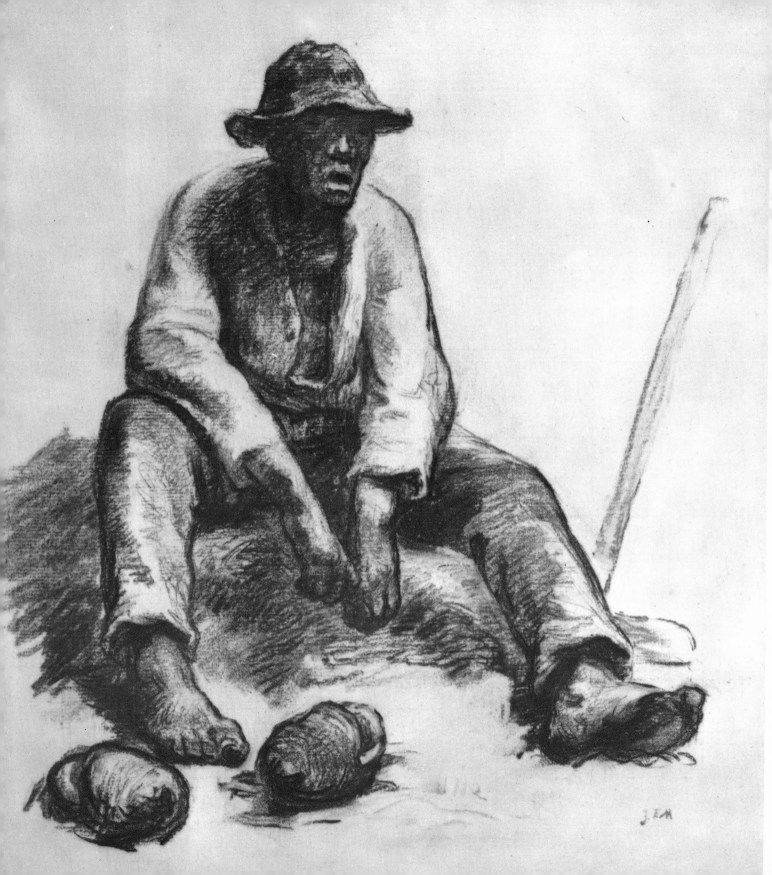

JEAN-FRANÇOIS MILLET
Child in a Tree
Black chalk,
heightened with white
Bradford, Pa.
T. Edward Hanley

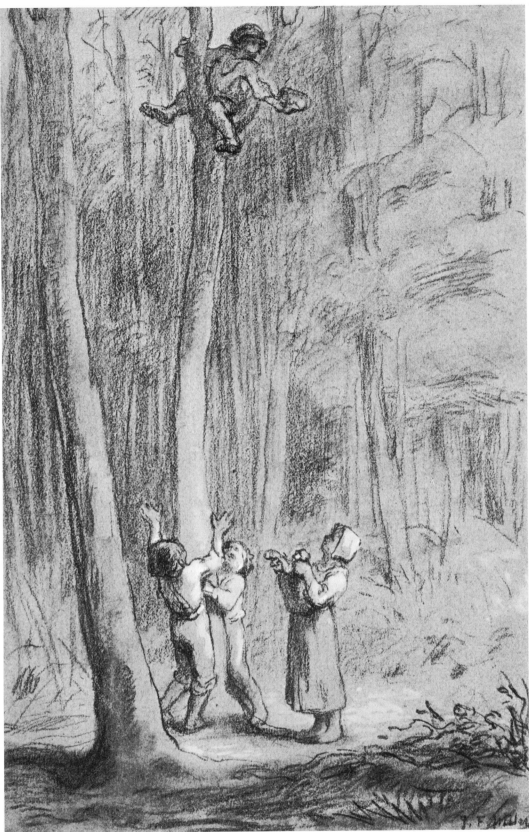

JEAN-FRANÇOIS MILLET
Peasant Resting
Black chalk on white paper
Oxford, Ashmolean Museum

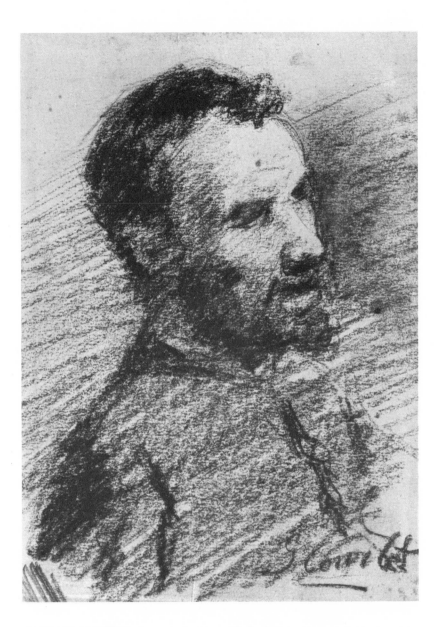

GUSTAVE COURBET · *Portrait of a Man* · Black chalk or crayon · Rotterdam, Museum Boymans

GUSTAVE COURBET · *Self-Portrait* · Charcoal on white paper · Hartford, Conn., Wadsworth Atheneum

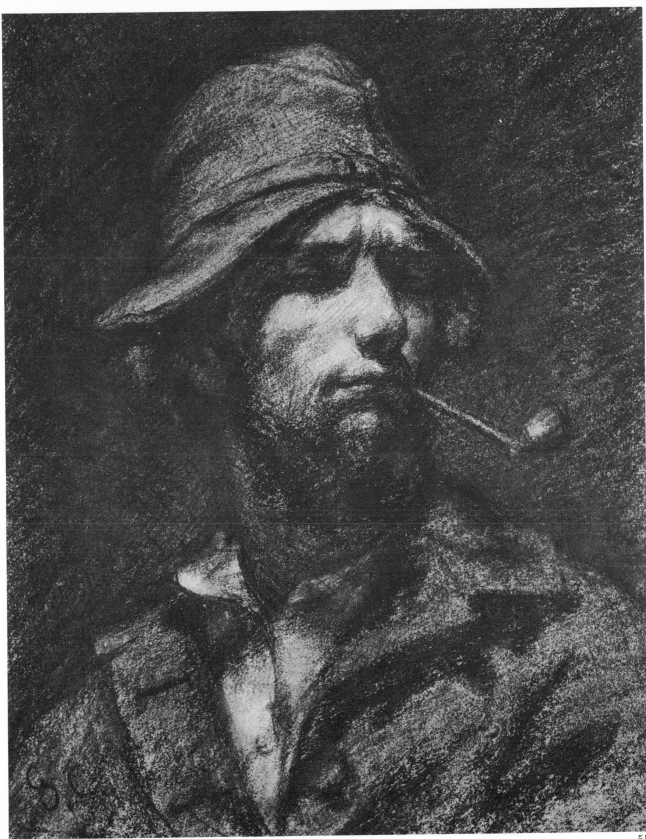

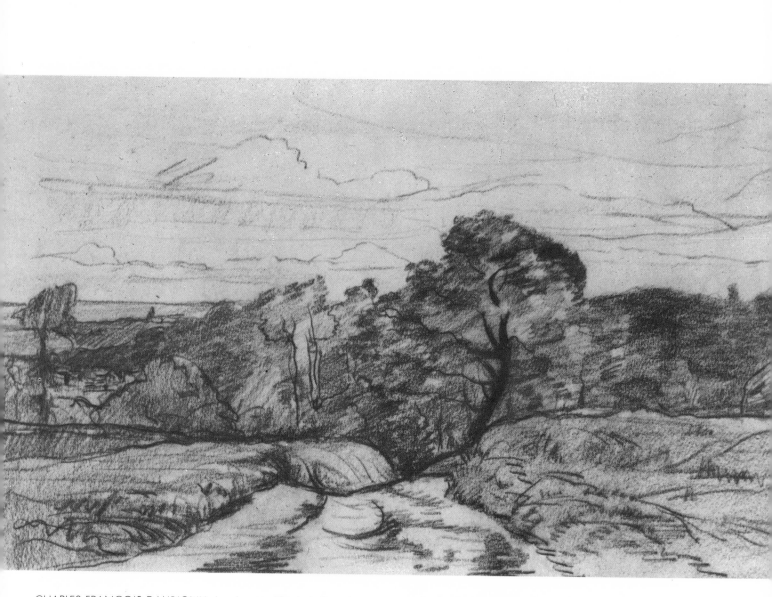

CHARLES FRANÇOIS DAUBIGNY · *Landscape* · Black chalk on brown paper · Budapest, Museum of Fine Arts

MAXIMILIEN LUCE · *Portrait of H. E. C.* · Black chalk on buff paper · New York, Robert Lehman

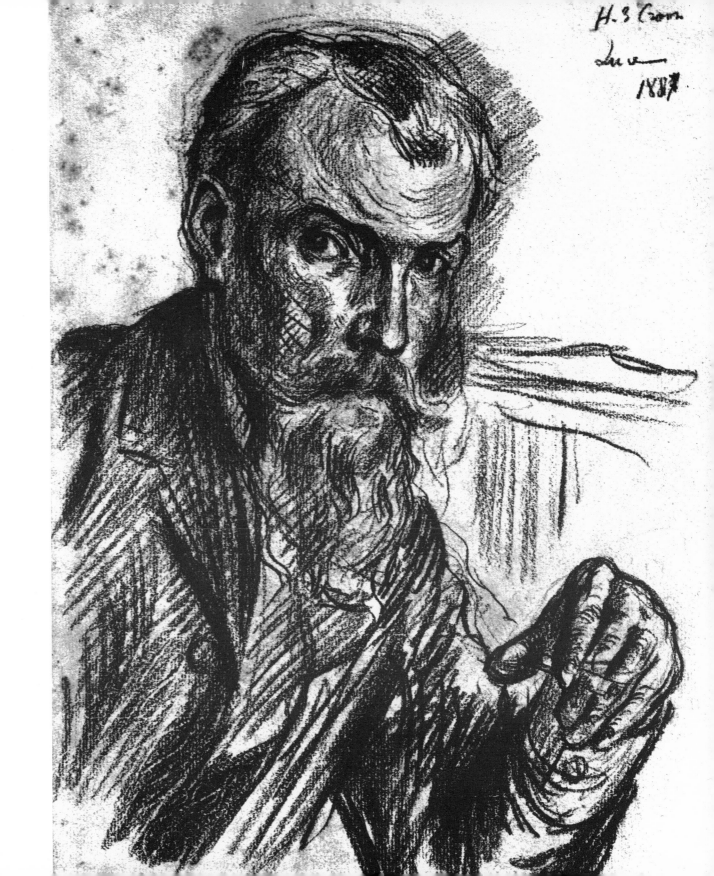

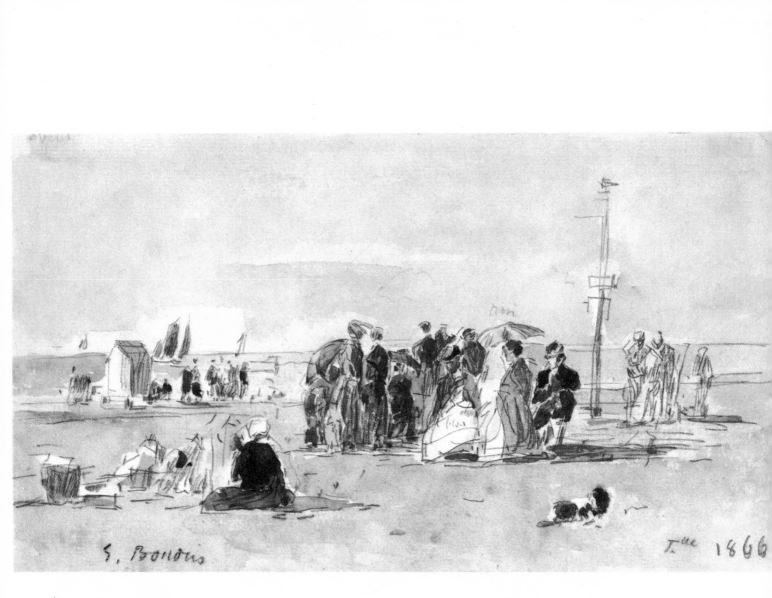

EUGÈNE BOUDIN · *Beach Scene* · Pencil with touches of water color · Alpine, N. J., Mr. and Mrs. Eugene V. Thaw

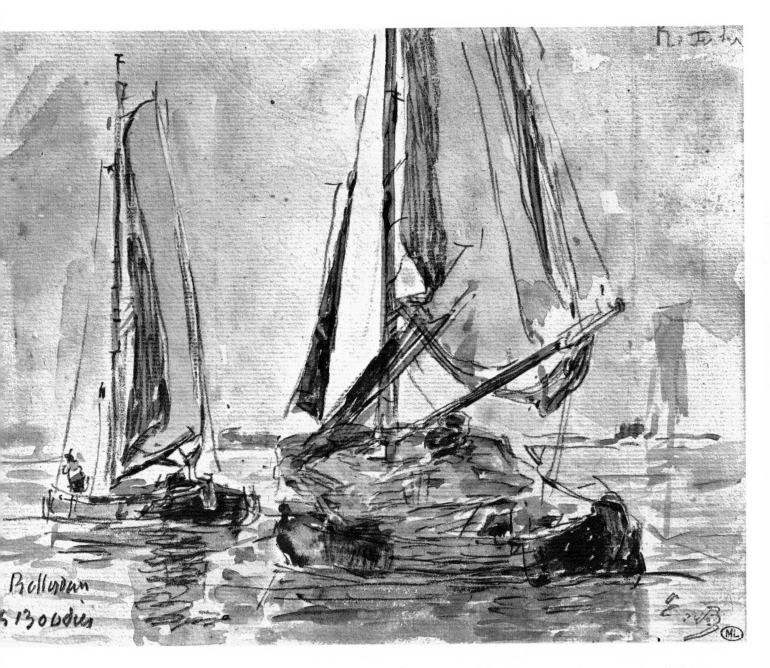

EUGÈNE BOUDIN · *Marine Scene* · Water color over pencil · Paris, Louvre

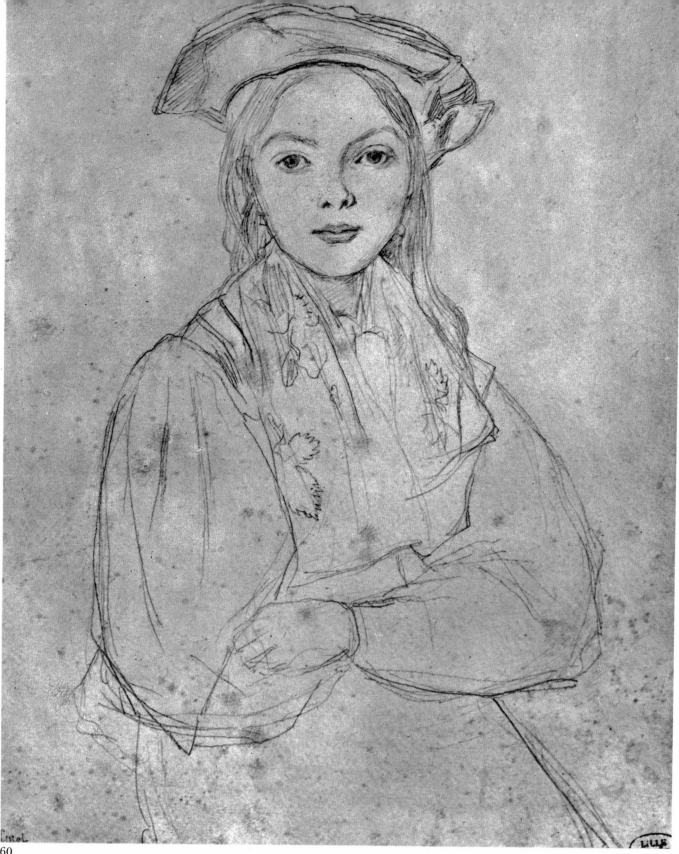

Emol

LILLE

60

JEAN-BAPTISTE CAMILLE COROT
Forest of Compiègne
Crayon and pen
Lille, Palais des Beaux-Arts
Musée Wicar

JEAN-BAPTISTE CAMILLE COROT
Girl in Beret
Pen and ink
Lille, Palais des Beaux-Arts
Musée Wicar

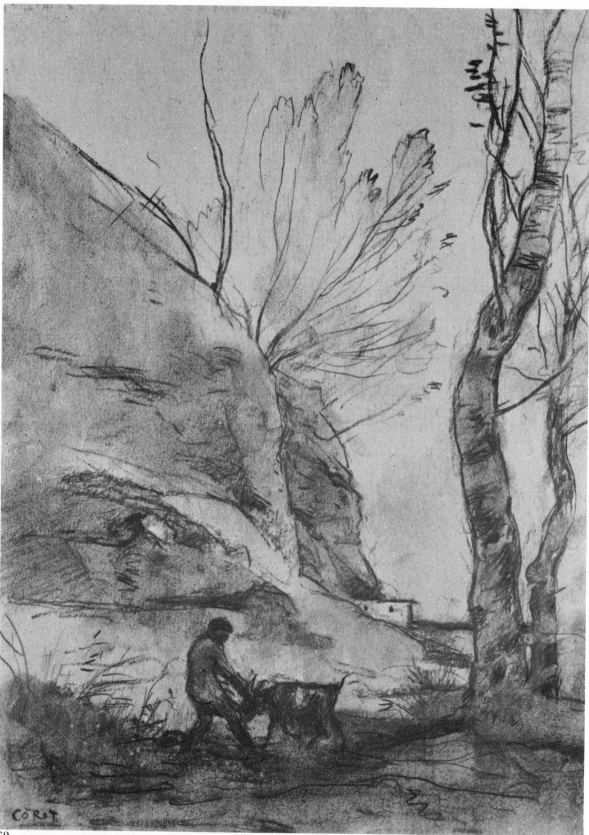

FÉLIX VALLOTTON
A Street in Paris
Pastel on heavy brown
wrapping paper
New York, Robert Lehman

JEAN-BAPTISTE
CAMILLE COROT
Shepherd with a Goat
Chalk and pencil
Budapest
Museum of Fine Arts

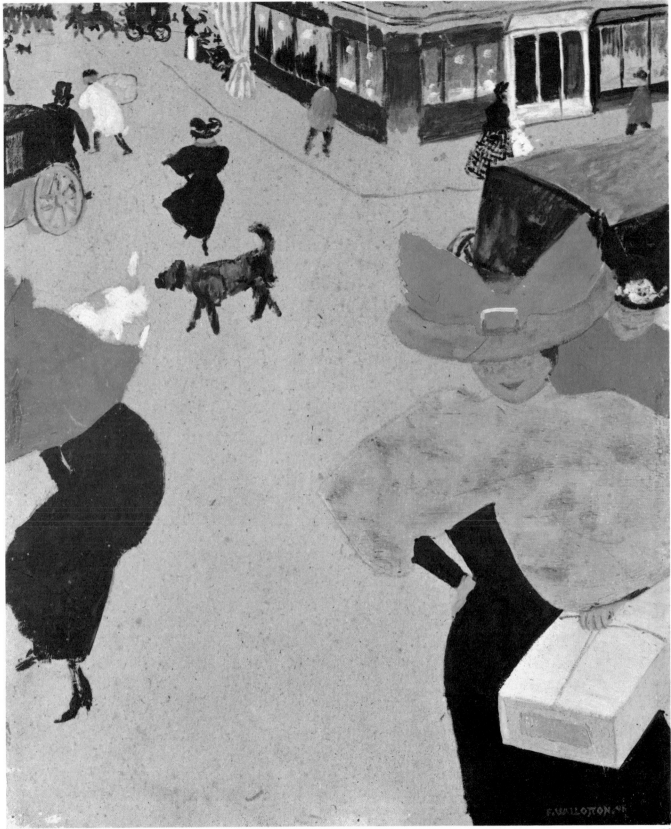

PIERRE PUVIS DE CHAVANNES · *Sketch for the Mural "Greek Colony" in the Palais de Longchamps, Marseilles*
Black and blue chalk · Budapest, Museum of Fine Arts

JEAN FRÉDÉRIC BAZILLE · *Manet Drawing* · Charcoal heightened with white chalk · New York, Robert Lehman

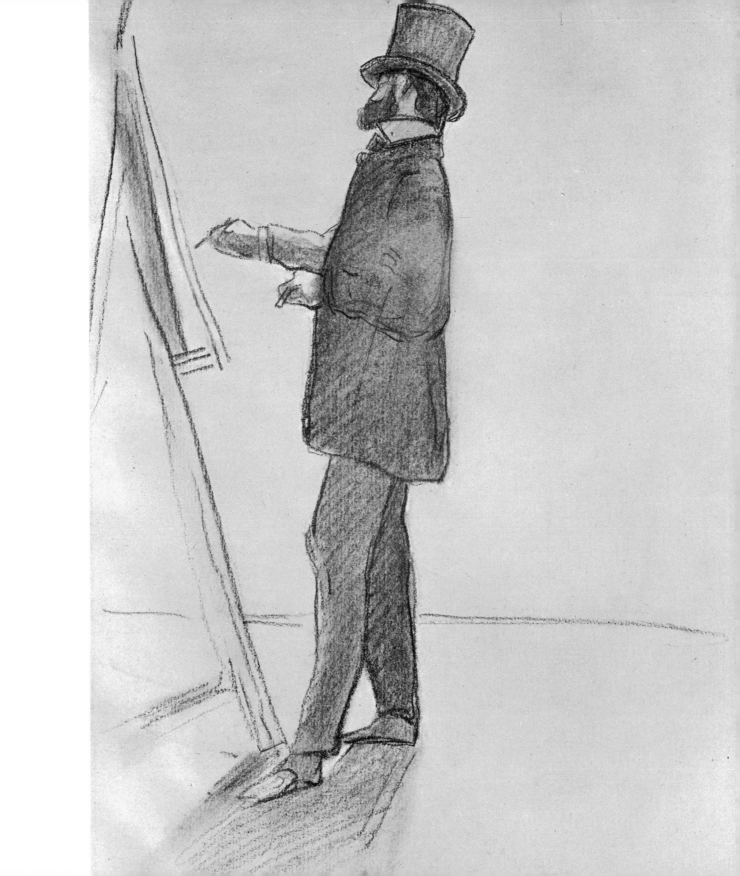

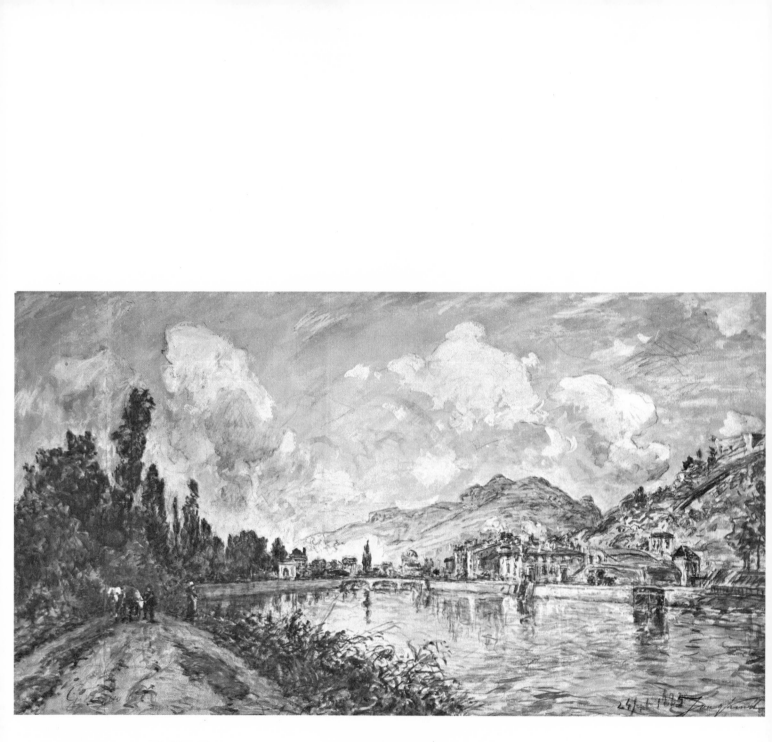

JOHAN BARTHOLD JONGKIND · *Bord de l'Isère à Grenoble* · Water color over black chalk · Paris, Louvre

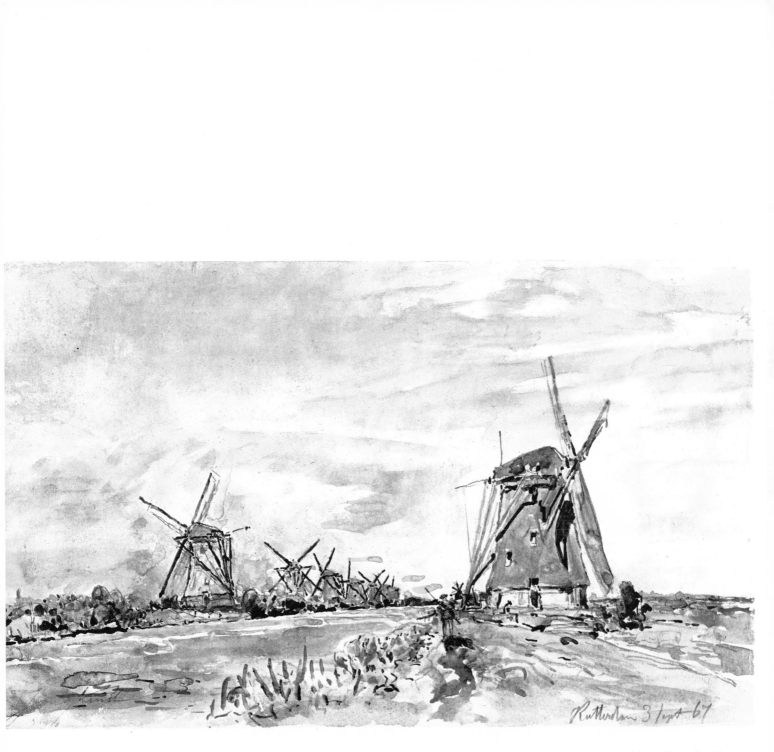

JOHAN BARTHOLD JONGKIND · *Windmills* · Water color and black chalk · Cambridge, Mass., Fogg Art Museum

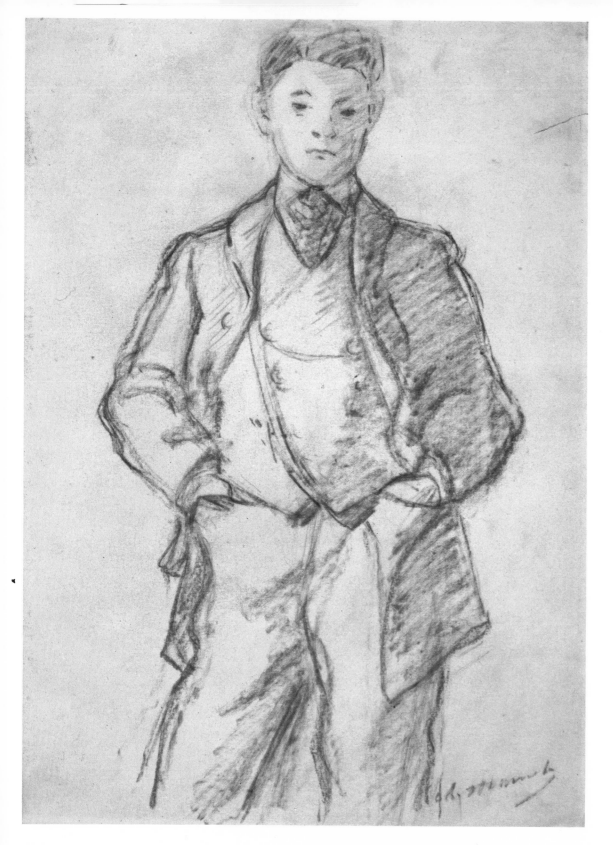

EDOUARD MANET
Study of a Boy
Sanguine
Rotterdam
Museum Boymans

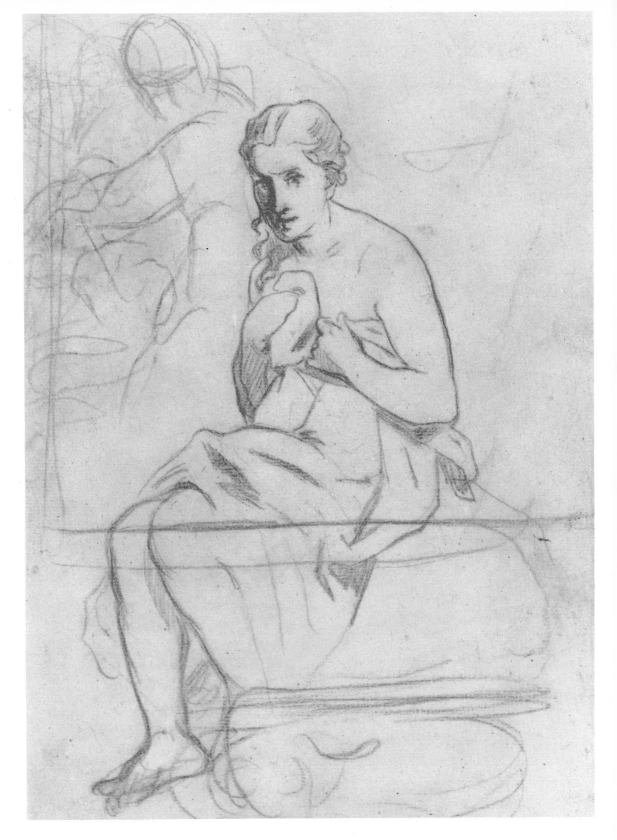

EDOUARD MANET
Woman at Her Toilet
Red Chalk
London,
Courtauld Institute

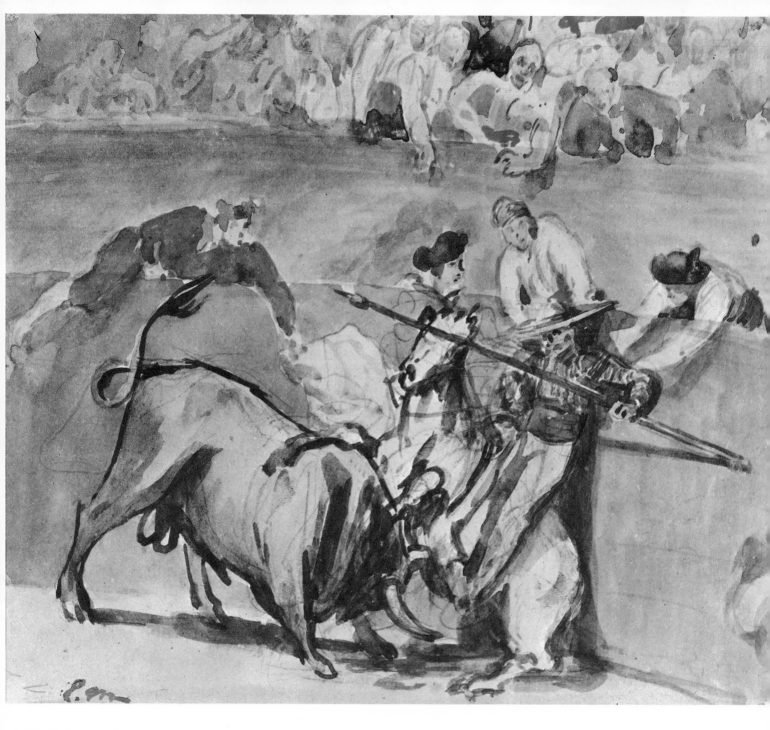

EDOUARD MANET · *Bullfight* · Water color · Paris, M. Scrölin

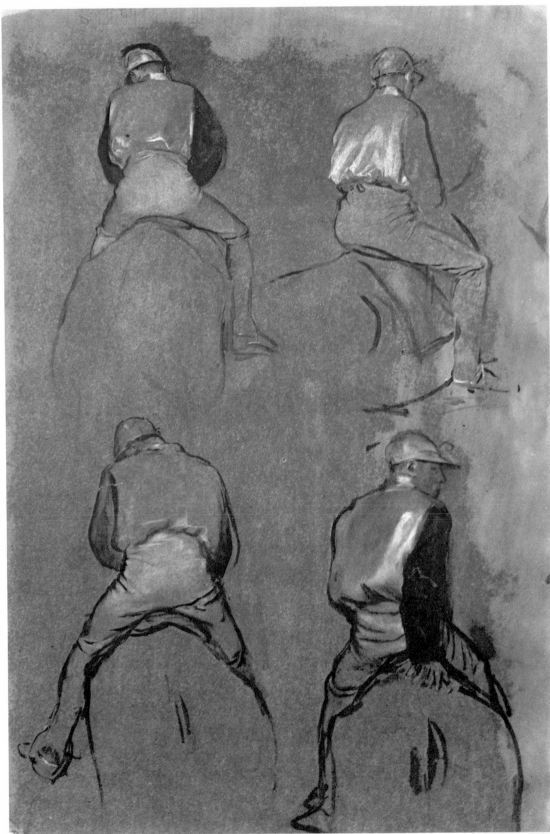

EDGAR DEGAS
Four Studies of a Jockey
Oil with brush,
heightened with white
Chicago, The Art Institute

71

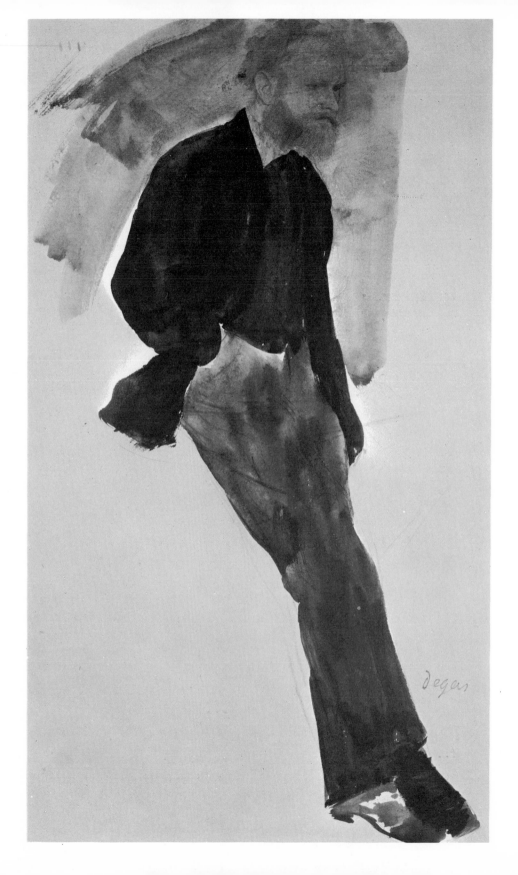

EDGAR DEGAS
Portrait of Edouard Manet
India ink and wash
Paris, Mme Ernest Rouart

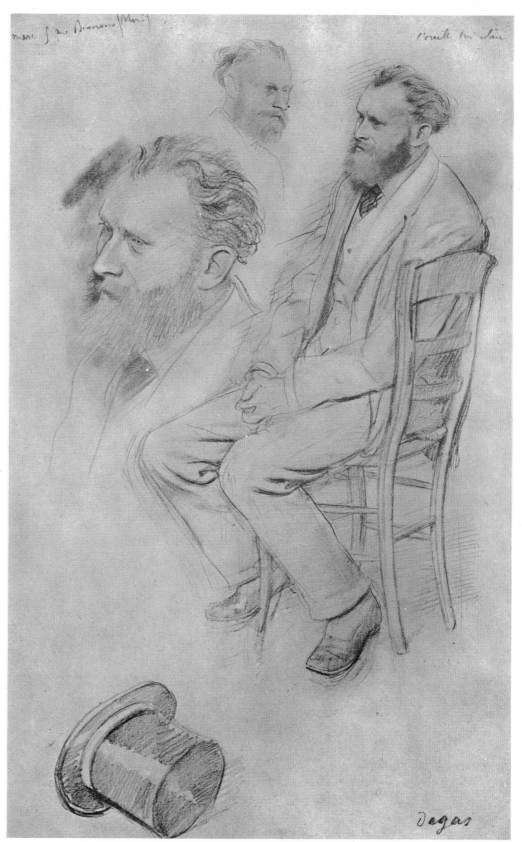

EDGAR DEGAS
Three Studies of Manet
Pencil
Paris, Mme Ernest Rouart

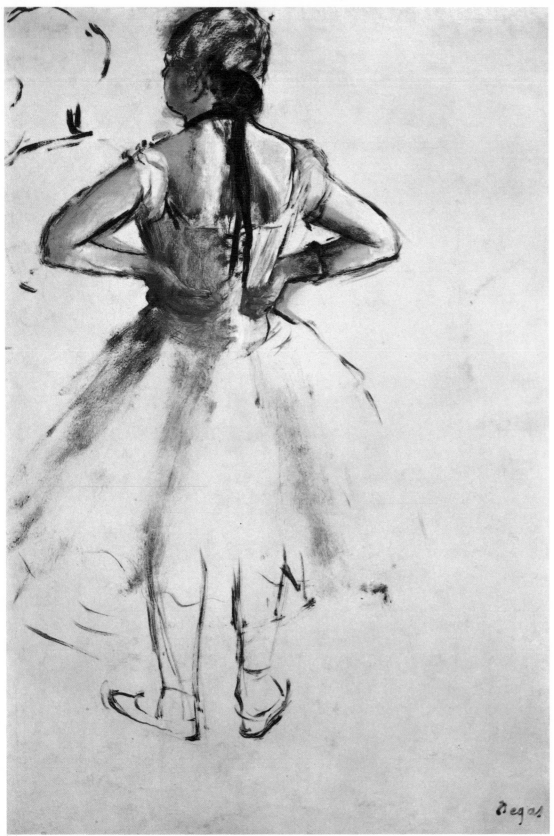

EDGAR DEGAS
Study of a Violinist
Charcoal, crayon, and pastel
New York
Metropolitan Museum of Art

EDGAR DEGAS
Ballet Dancer
Brush sketch in oil
on pink paper
Paris, Louvre

74

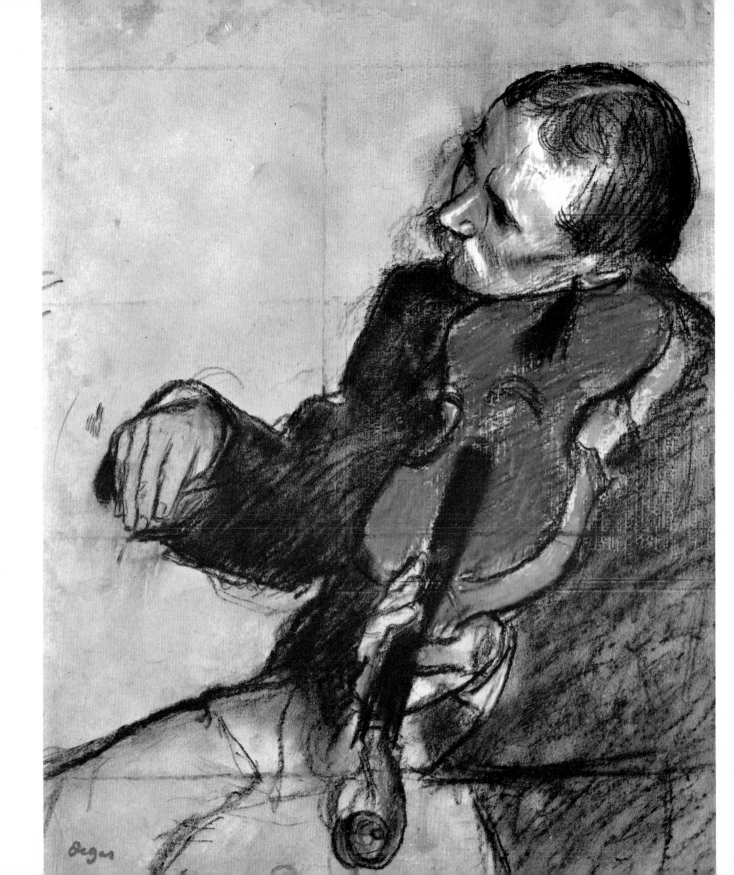

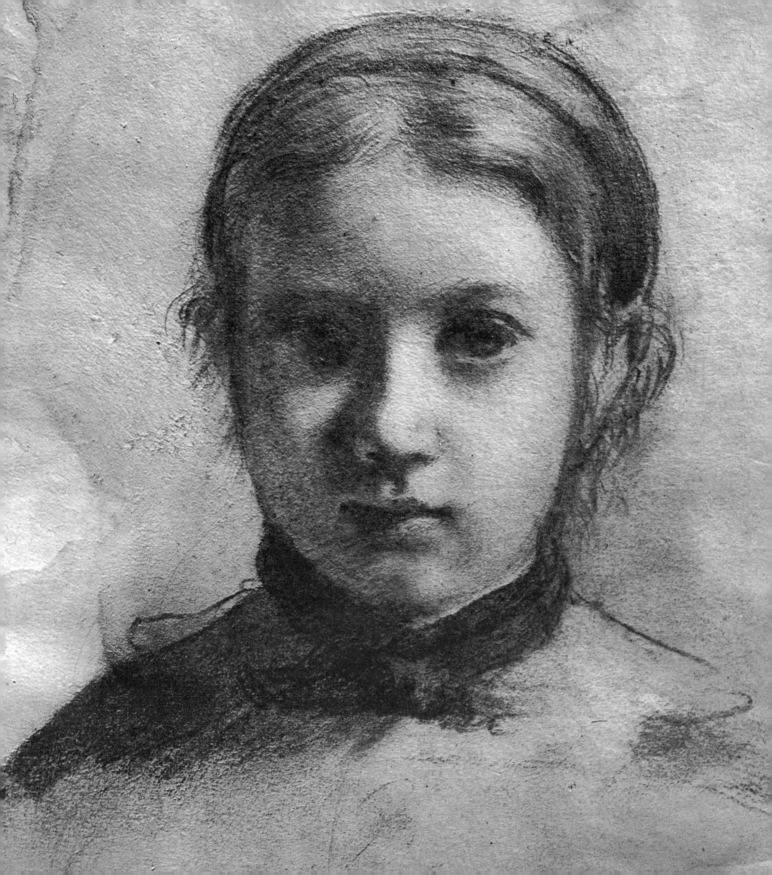

EDGAR DEGAS
Young Woman Yawning
Crayon with green pastel
Bradford, Pa.
T. Edward Hanley

EDGAR DEGAS
Portrait of Giovanna Bellelli
Black chalk on brownish paper
Paris, Louvre

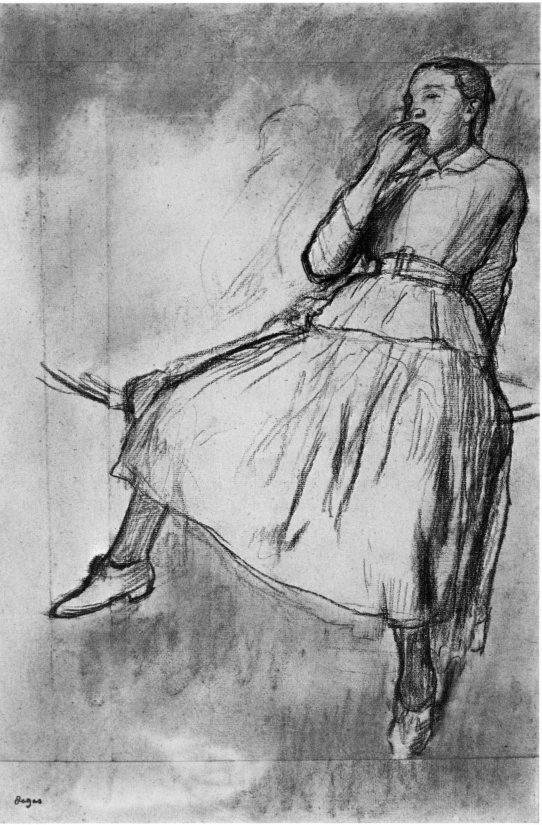

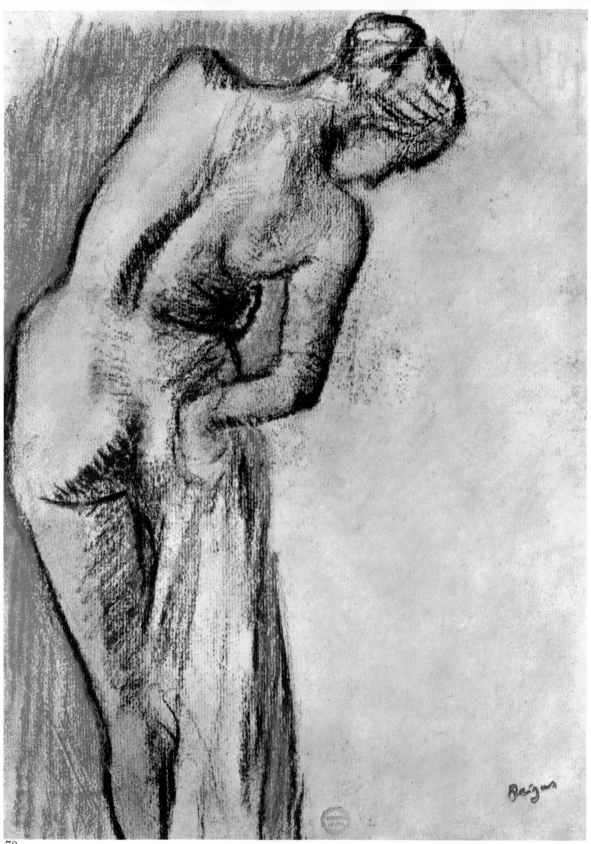

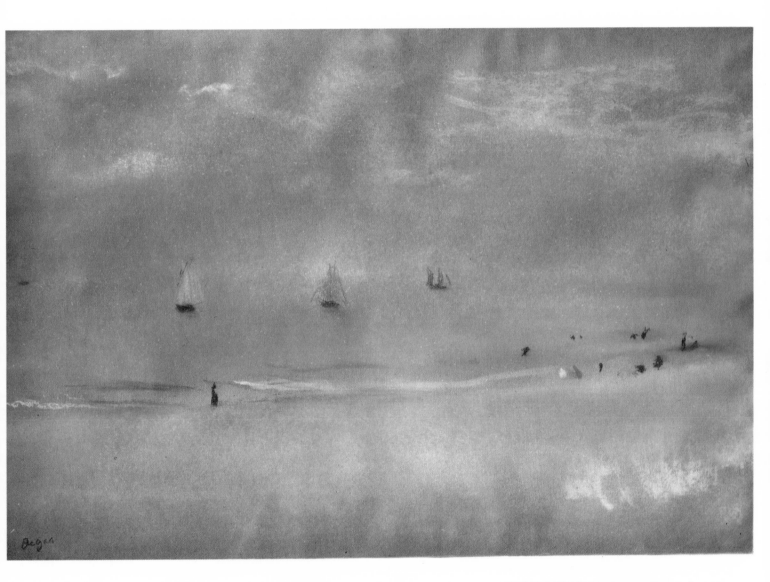

EDGAR DEGAS · *Landscape* · Pastel · Paris, Louvre

EDGAR DEGAS · *Nude After the Bath* · Charcoal, crayon, and pastel · New York, Metropolitan Museum of Art

CLAUDE MONET · *Seascape, Normandy Coast* · Charcoal · Bradford, Pa., T. Edward Hanley

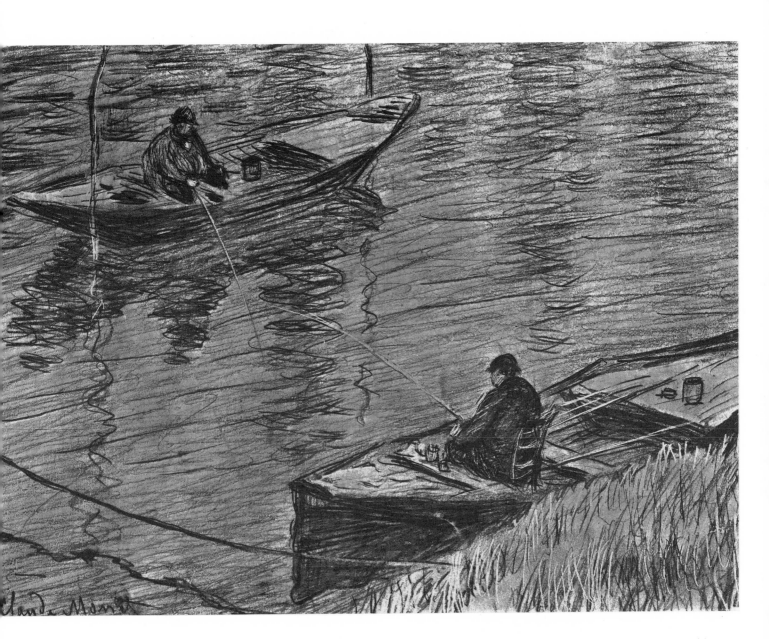

CLAUDE MONET · *Two Men Fishing* · Black crayon on white scratchboard · Cambridge, Mass., Fogg Art Museum

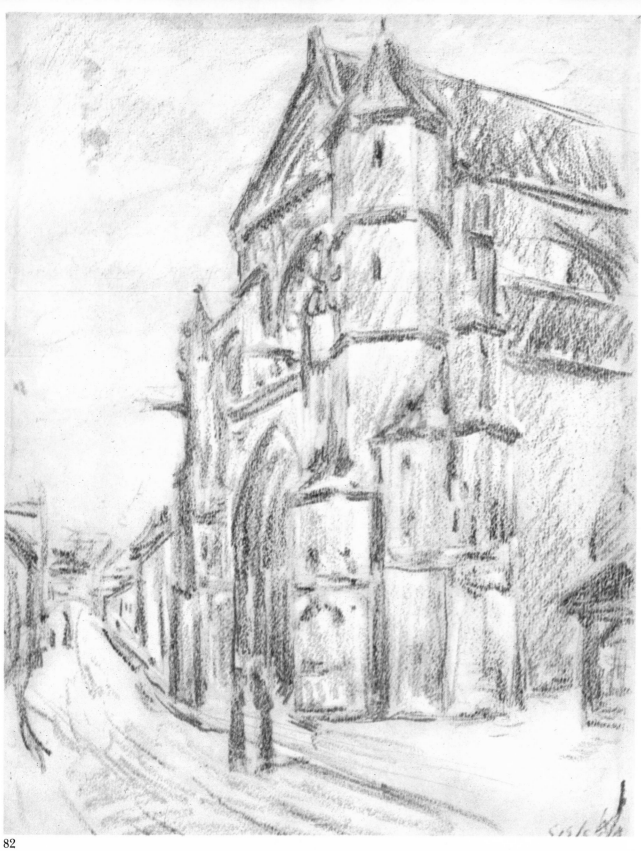

CAMILLE PISSARRO
Girl Arranging Her Hair
Colored chalks
New York
Mrs. Siegfried Kramarsky

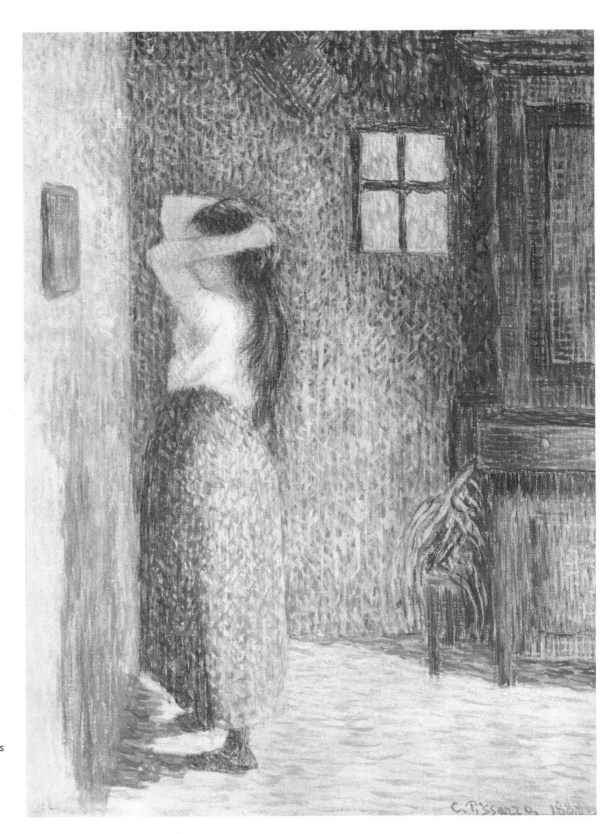

ALFRED SISLEY
The Church at Moret
Pastel
Budapest, Museum of Fine Arts

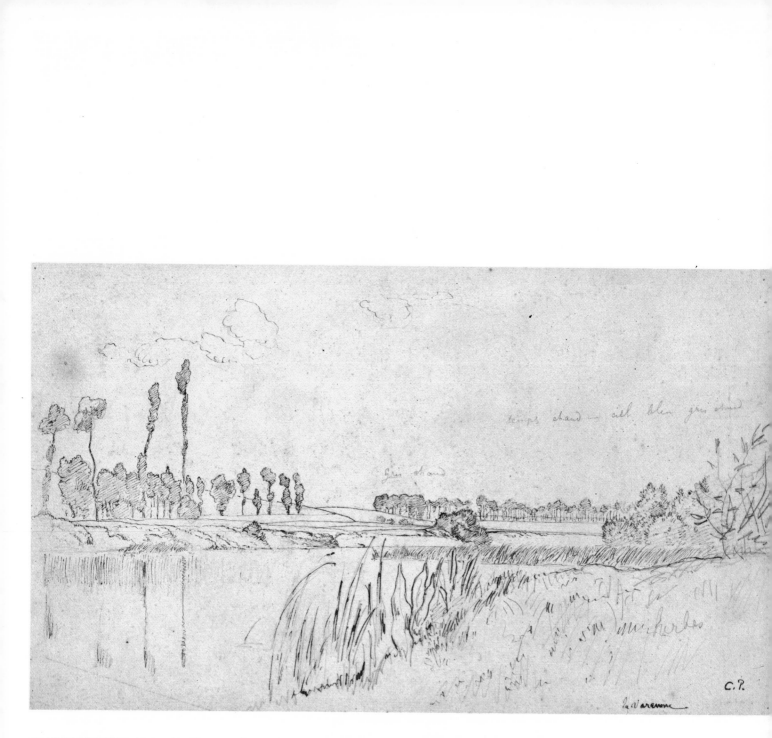

CAMILLE PISSARRO · *View of La Varenne* · Pen and ink over pencil · New York, Curtis O. Baer

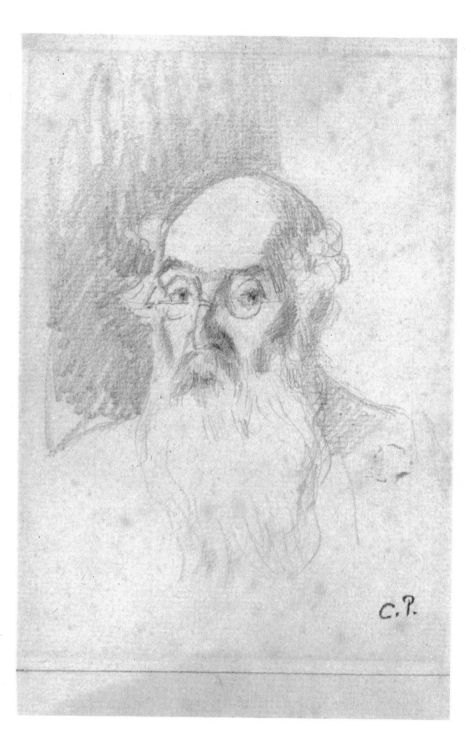

CAMILLE PISSARRO
Self-Portrait
Pencil
New York, John S. Newberry

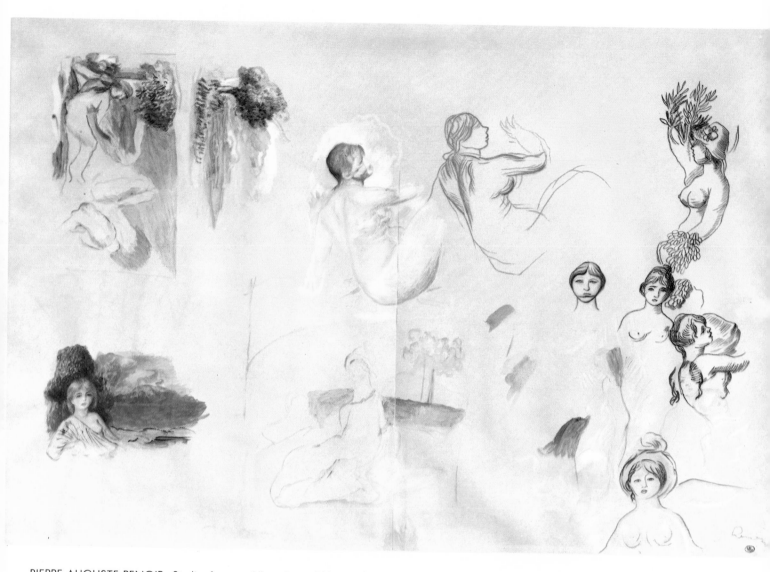

PIERRE-AUGUSTE RENOIR · *Studies from an Album Page* · Water color, pencil, pen, heightened with wash · Paris, Louvre

PIERRE-AUGUSTE RENOIR · *Jean Renoir and Gabrielle* · Black chalk · Ottawa, National Gallery of Canada

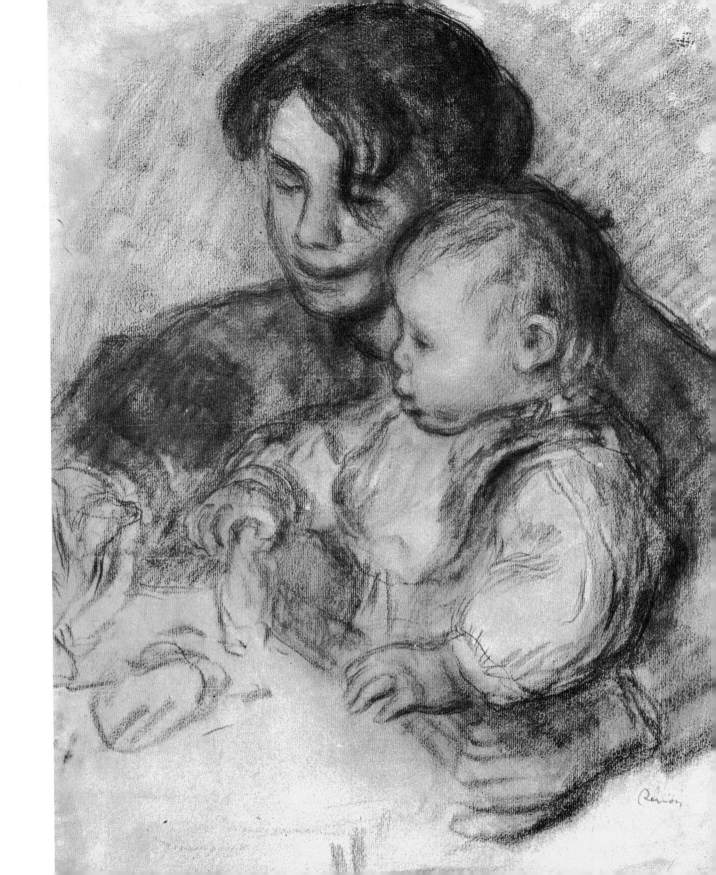

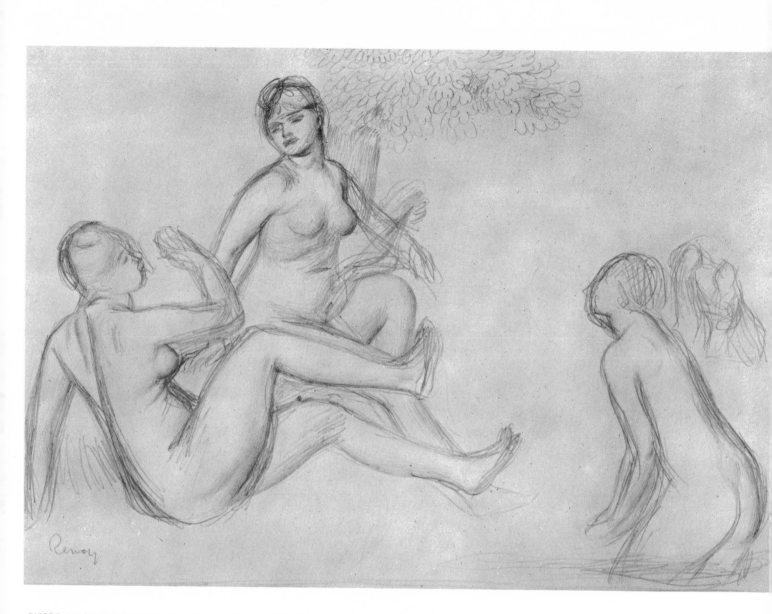

PIERRE-AUGUSTE RENOIR · *The Bathers* · Pencil · Hartford, Conn., Wadsworth Atheneum

PIERRE-AUGUSTE RENOIR · *Female Nude Seated* · Black chalk on tan paper · New York, David Daniels

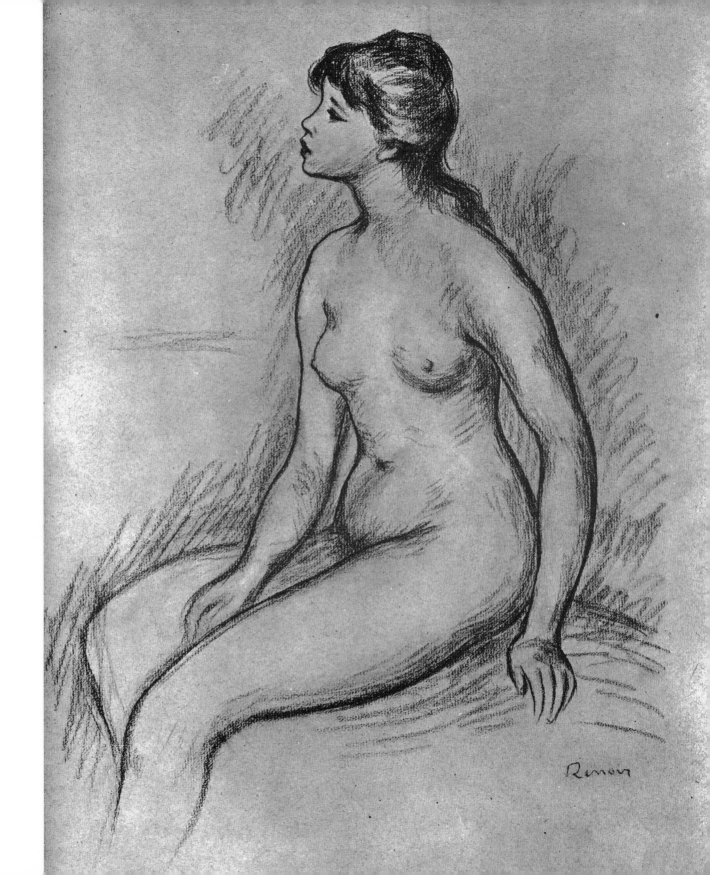

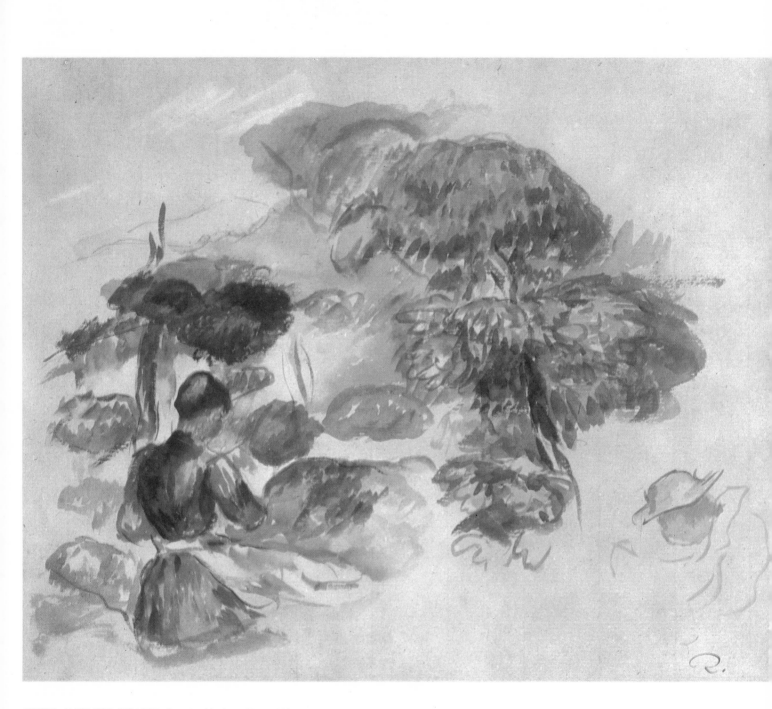

PIERRE-AUGUSTE RENOIR • *Figures Under a Tree* • Water color • New York, Robert Lehman

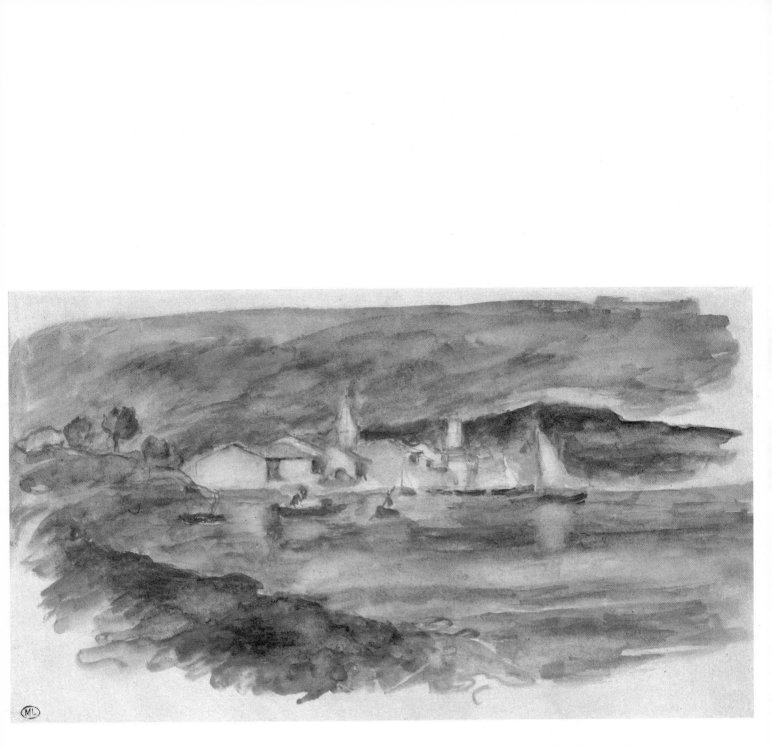

PIERRE-AUGUSTE RENOIR · *Fishing Village* · Water color · Paris, Louvre

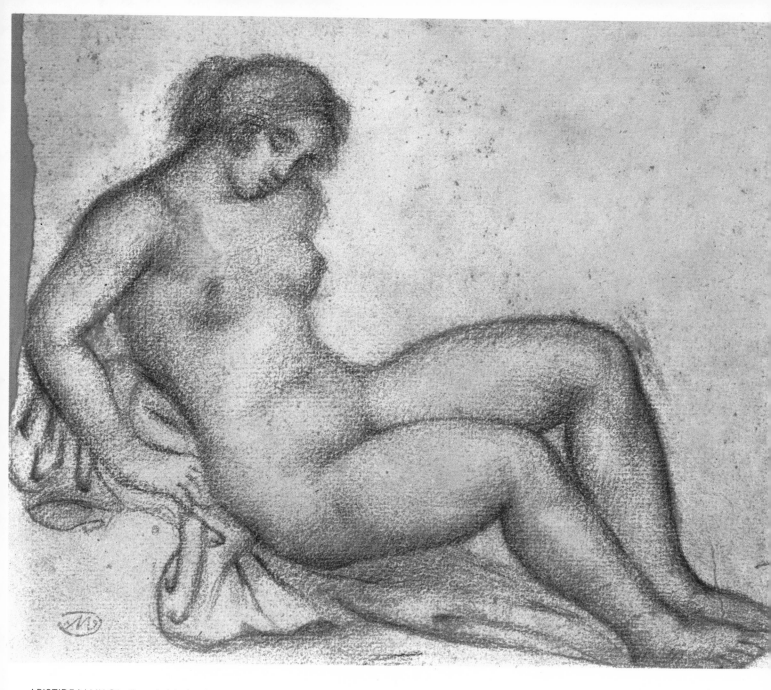

ARISTIDE MAILLOL · *Female Nude* · Sanguine · Bradford, Pa., T. Edward Hanley

ARISTIDE MAILLOL · *Two Female Nudes* · Black chalk heightened with white · Paris, Alfred Daber

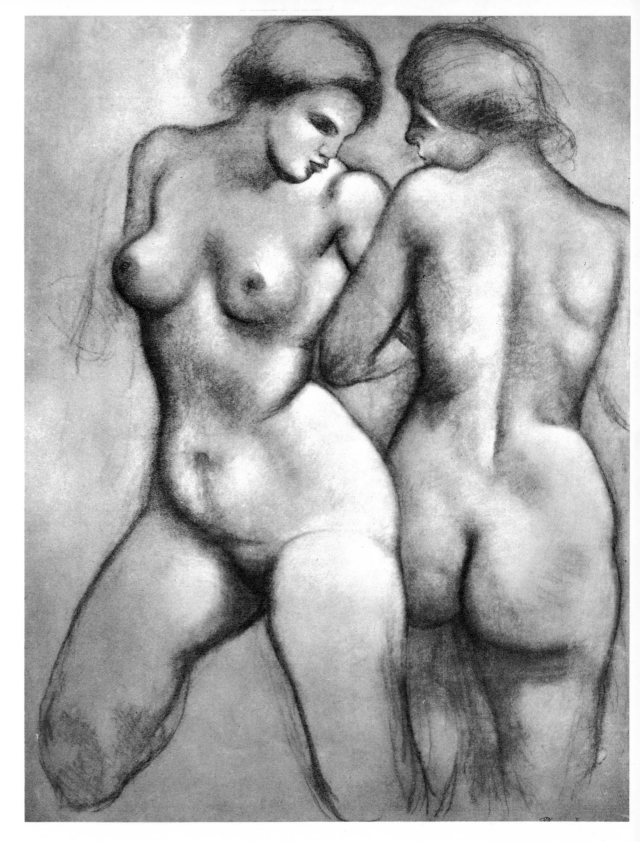

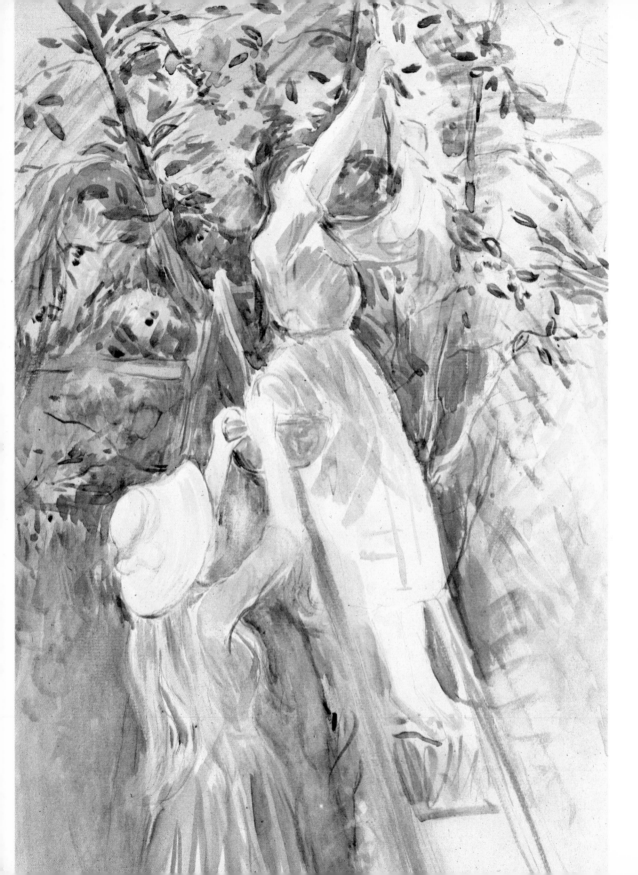

BERTHE MORISOT
The Cherry Tree
Water color
Paris, Mme Ernest Rouart

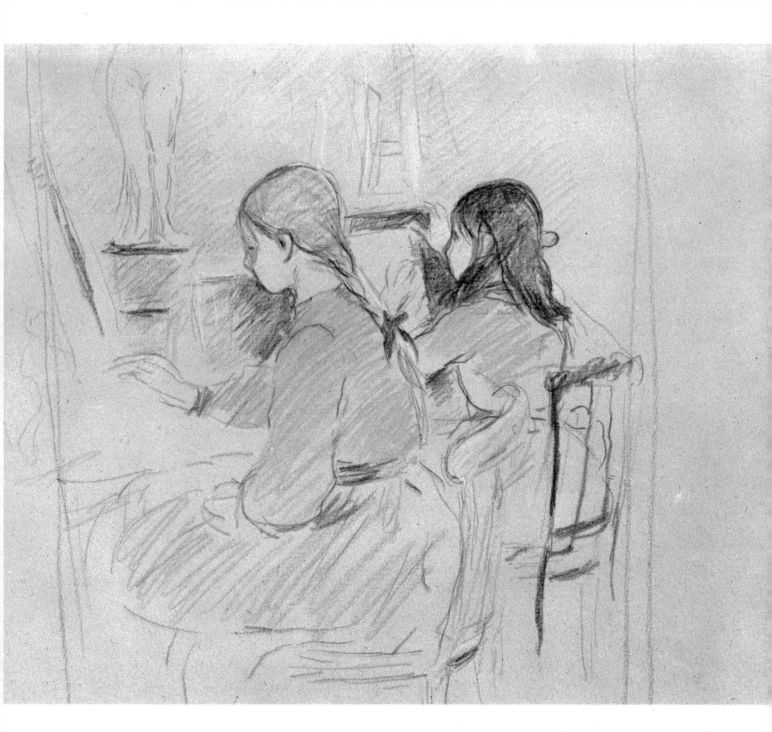

BERTHE MORISOT • *Study for "At the Piano"* • Pastel • Paris, Mme Ernest Rouart

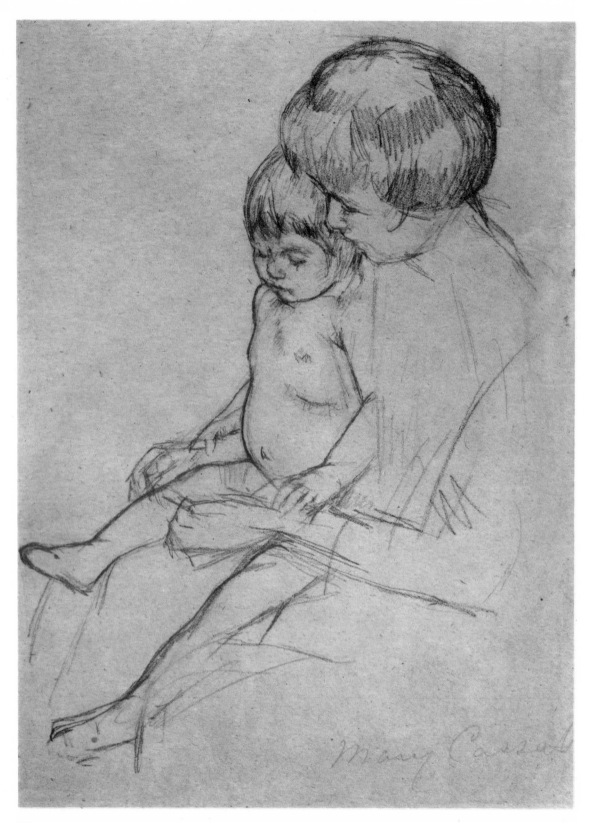

MARY CASSATT
Mother and Child
Pencil
Providence, R. I.
School of Design

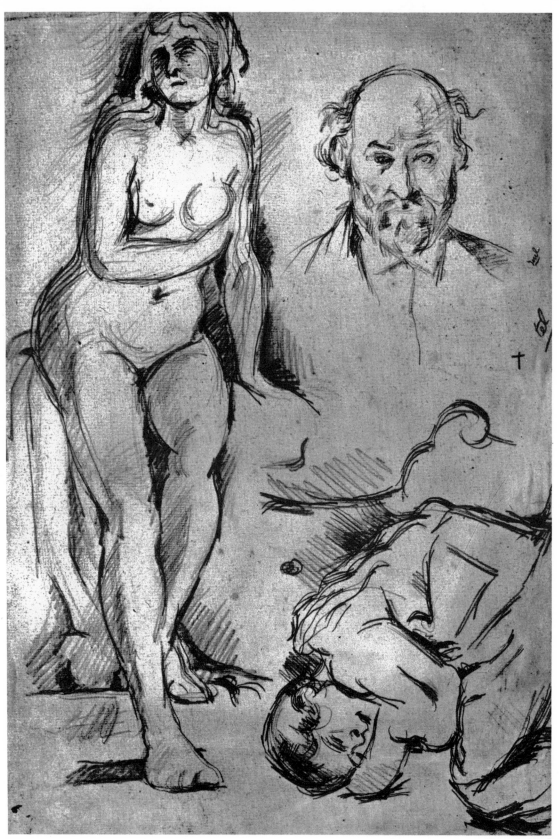

PAUL CÉZANNE
Studies
Pencil
Rotterdam, Museum Boymans

97

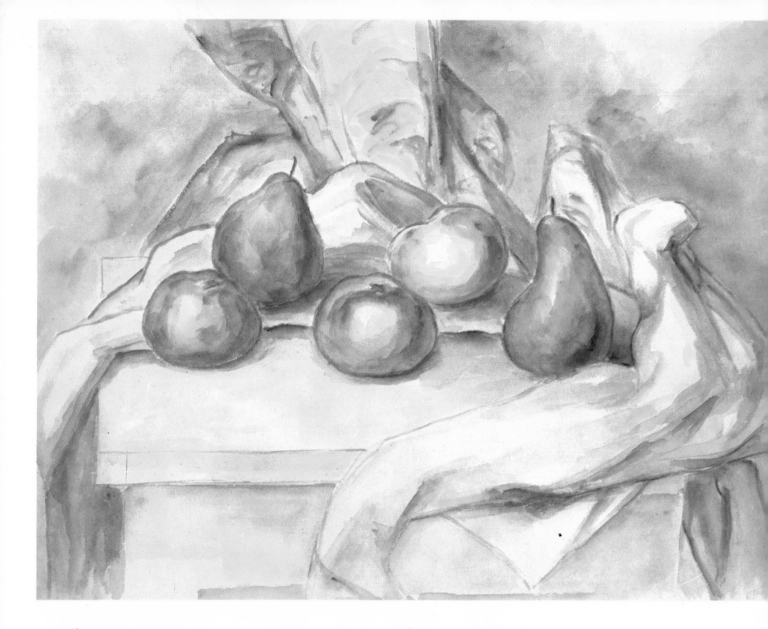

PAUL CÉZANNE · *Still Life with Pears and Apples* · Water color · New York, Mrs. Siegfried Kramarsky

PAUL CÉZANNE · *Olympia* · Water color · New York, Estate of Louis E. Stern

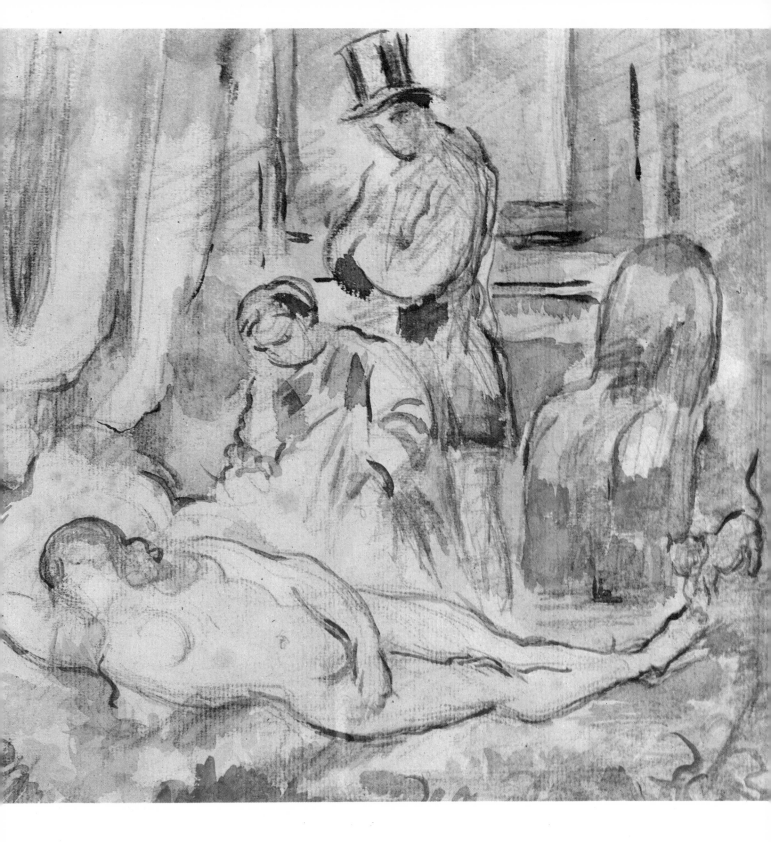

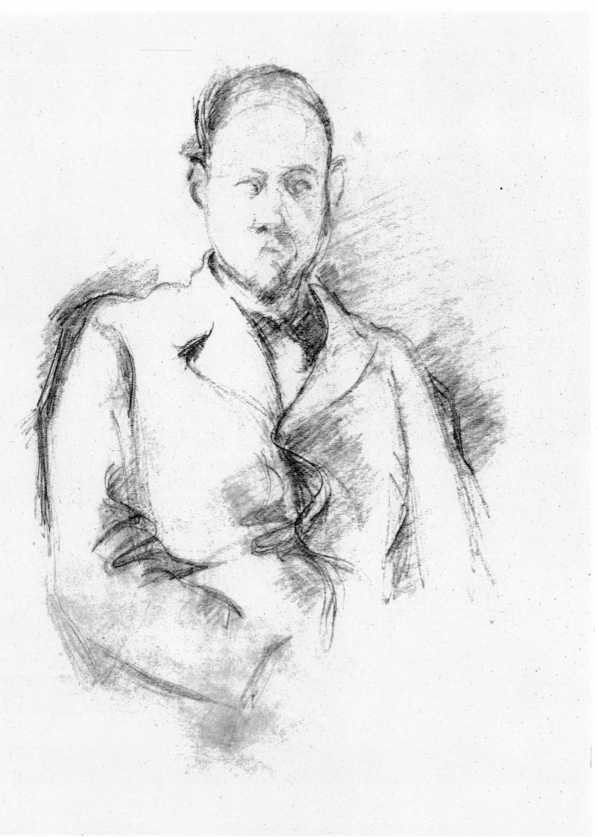

PAUL CÉZANNE
Portrait of Vollard
Pencil
Cambridge, Mass.
Fogg Art Museum

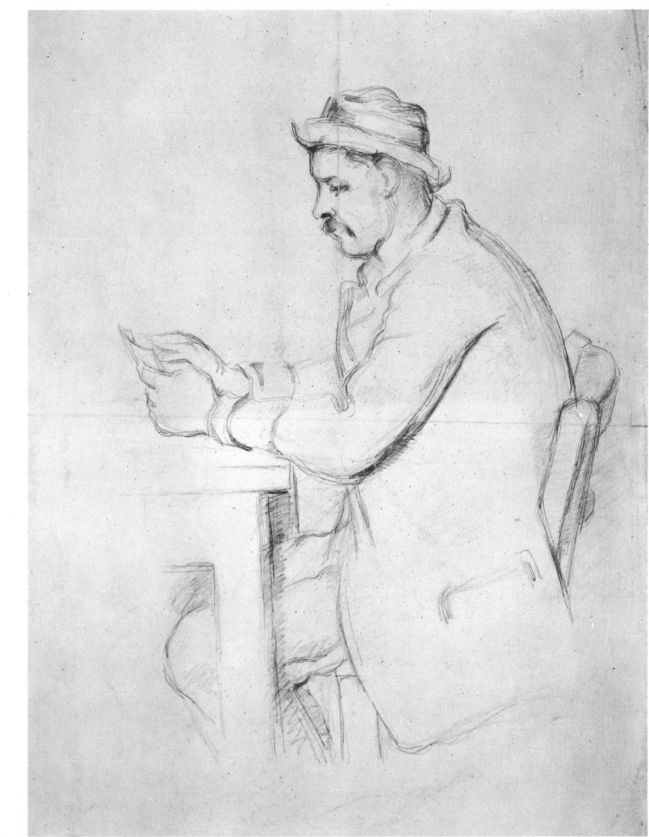

PAUL CÉZANNE
Study for
'The Card Players"
Pencil
Bradford, Pa.
T. Edward Hanley

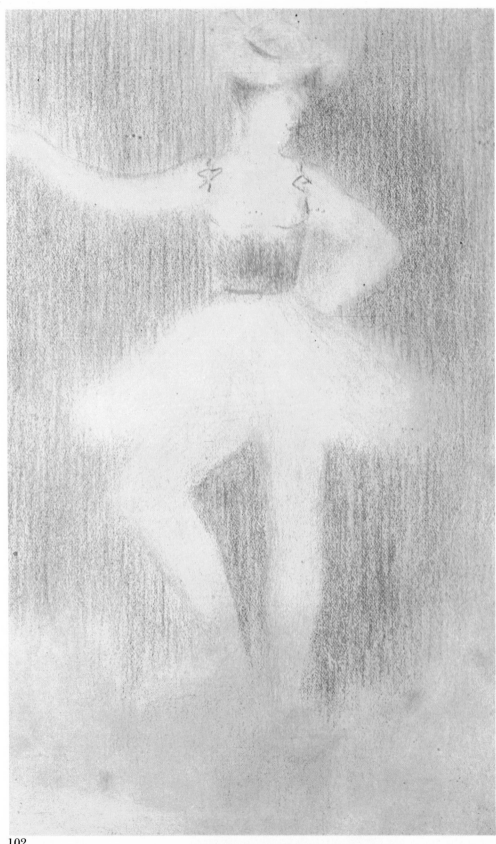

GEORGES SEURAT
Ballerina
Conté crayon
New York
Mrs. Siegfried Kramarsky

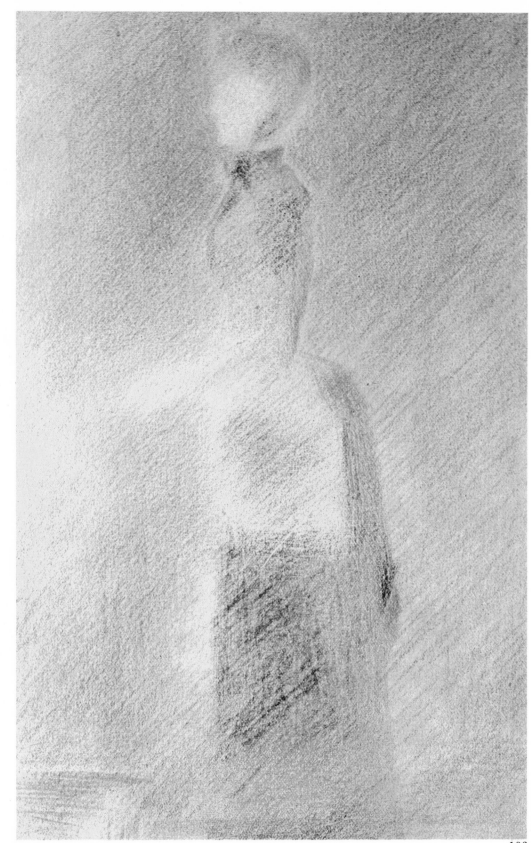

GEORGES SEURAT
Standing Woman
Colored crayons
New York
Mrs. Siegfried Kramarsky

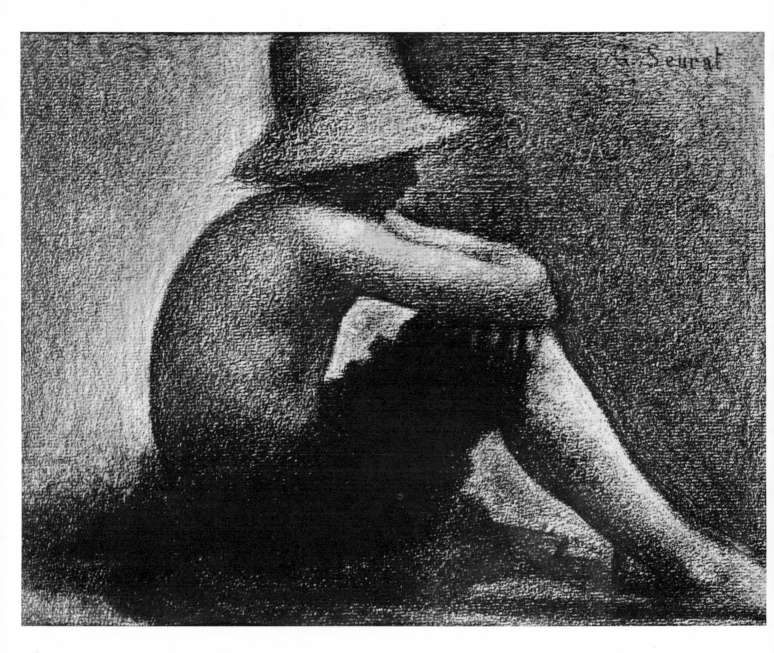

GEORGES SEURAT • *Study for "The Bathers"* • Conté crayon • New Haven, Yale University Art Gallery

GEORGES SEURAT • *At the Concert Européen* • New York, Museum of Modern Art

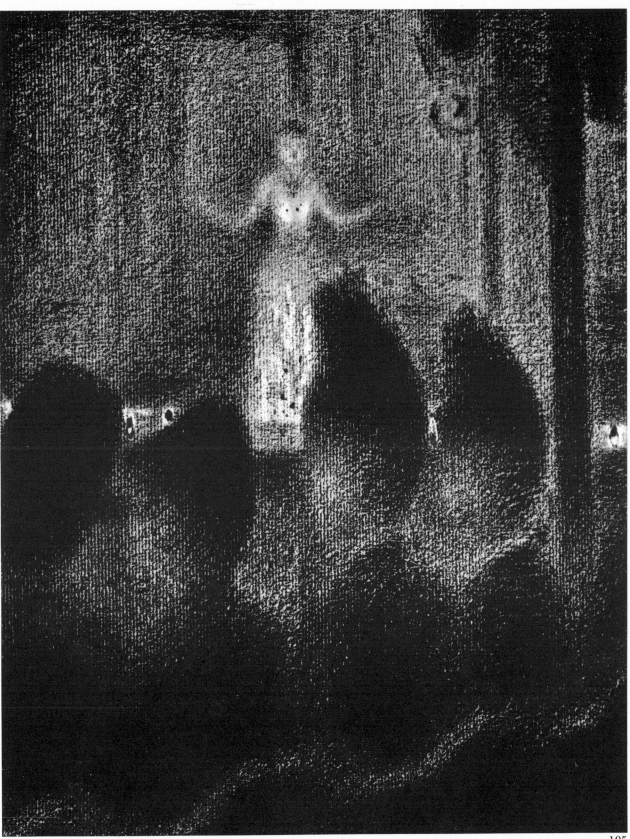

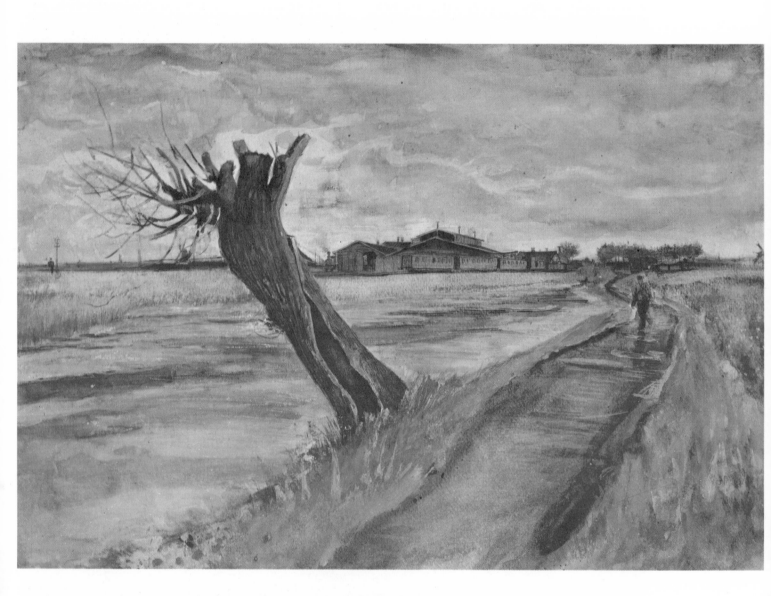

VINCENT VAN GOGH · *Landscape* · Water color and chalks · New York, Leo M. Rogers

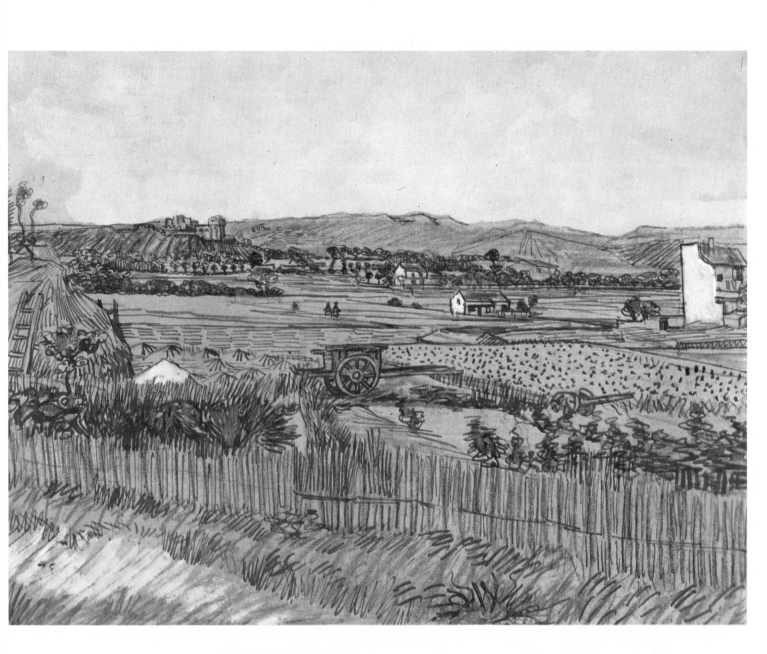

VINCENT VAN GOGH · *The Blue Cart* · Pen and brown ink with colored chalk, water color, and gouache
Cambridge, Mass., Fogg Art Museum

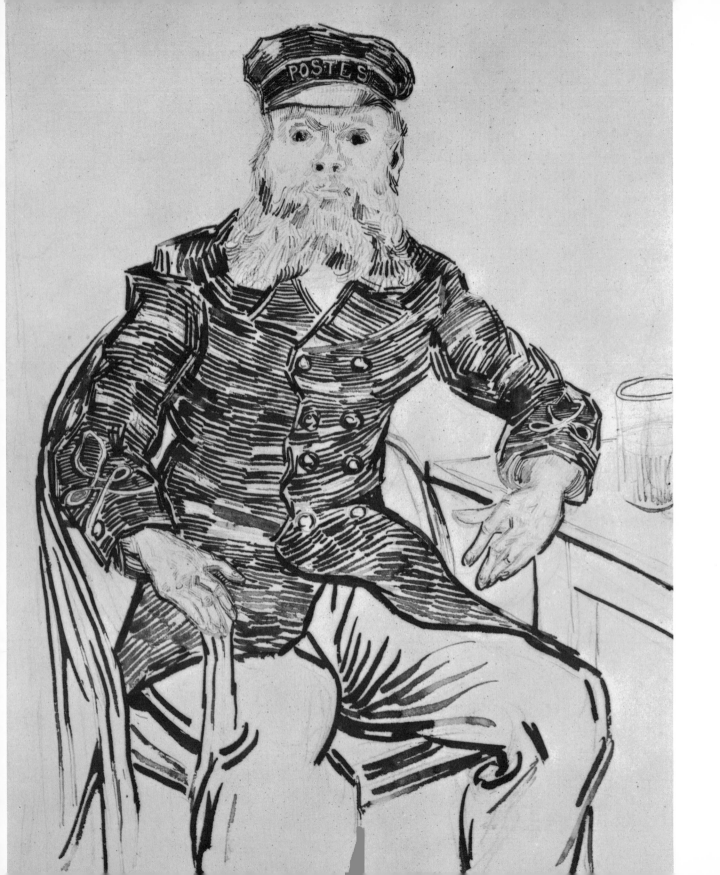

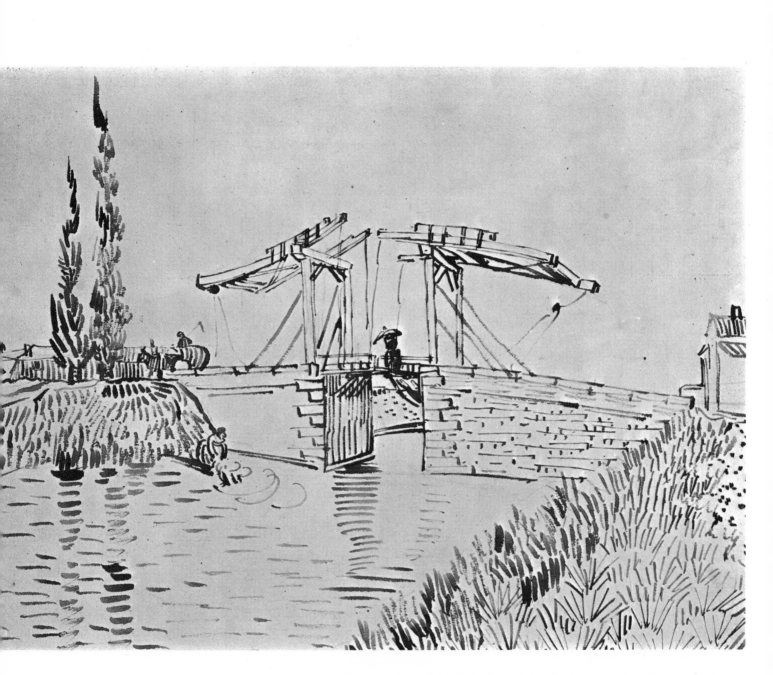

VINCENT VAN GOGH · *Bridge at Arles* · Reed pen · Los Angeles County Museum

VINCENT VAN GOGH · *The Postman, Roulin* · India ink and black crayon with reed pen · Los Angeles County Museum

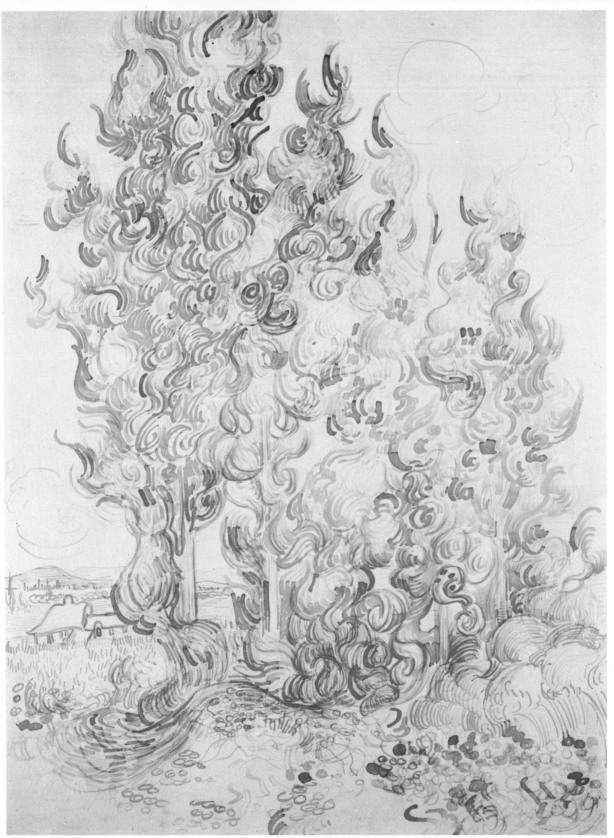

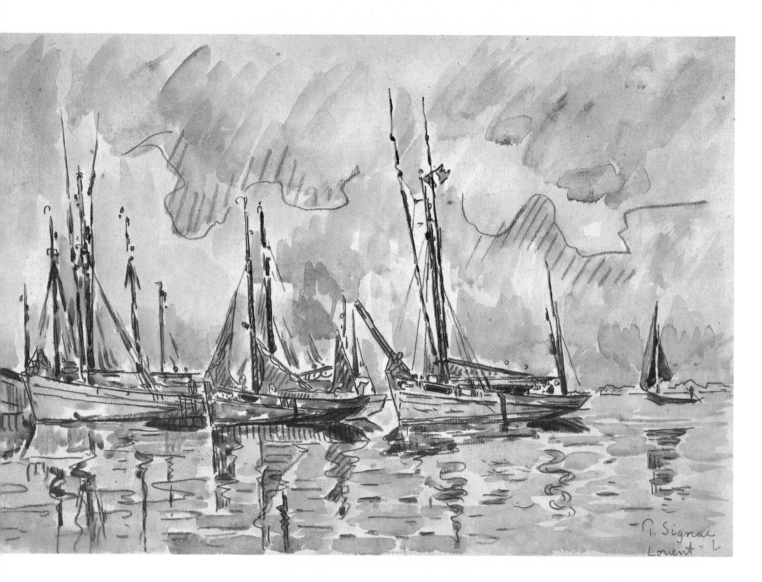

PAUL SIGNAC · *L'Orient* · Water color · Paris, Musée d'Art Moderne

NCENT VAN GOGH · *Grove of Cypresses* · Reed pen and brown ink over pencil · Chicago, The Art Institute

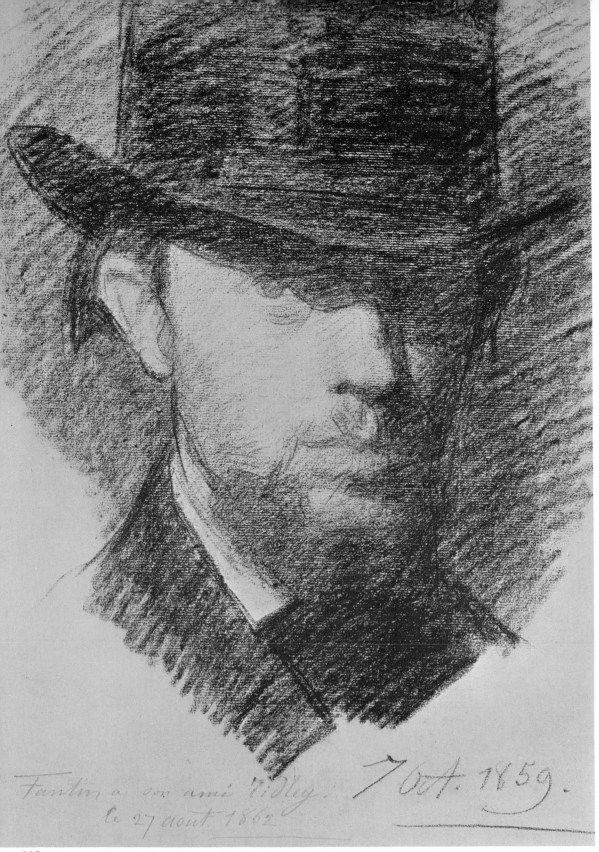

Fantin à son ami Ridley. 7 oct. 1859.
le 27 août 1862

HENRI FANTIN-LATOUR
Self-Portrait
Charcoal
Bradford, Pa.
T. Edward Hanley

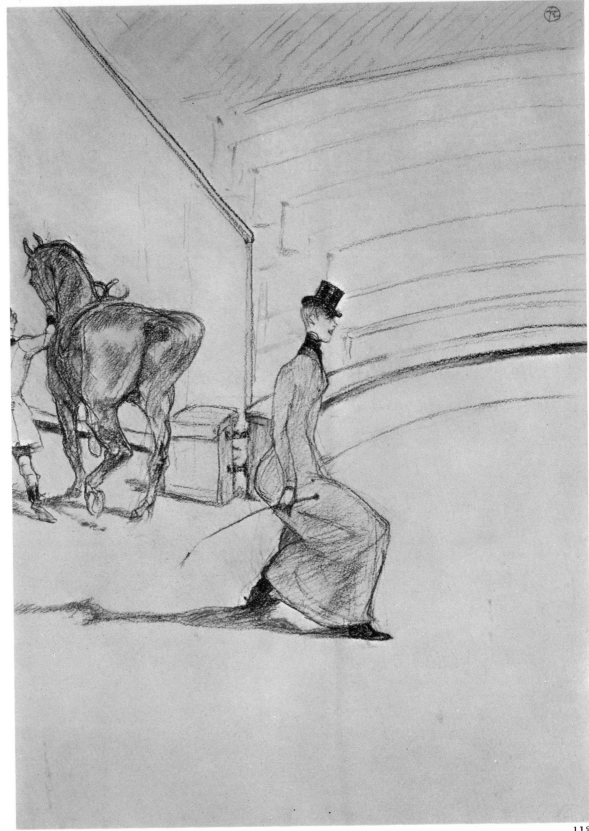

TOULOUSE-LAUTREC
Au Cirque
Black crayon
Bradford, Pa.
T. Edward Hanley

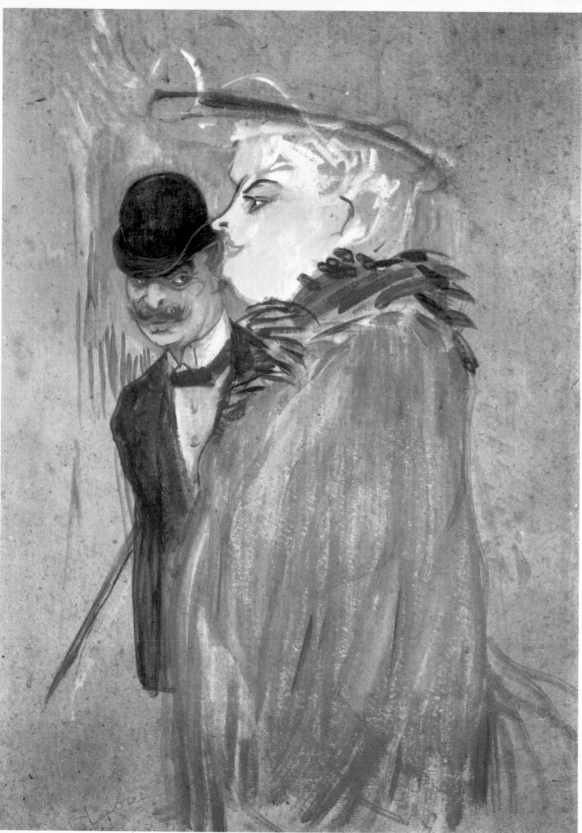

TOULOUSE-LAUTREC
Couple
Water color
New York
Mrs. Siegfried Kramarsky

114

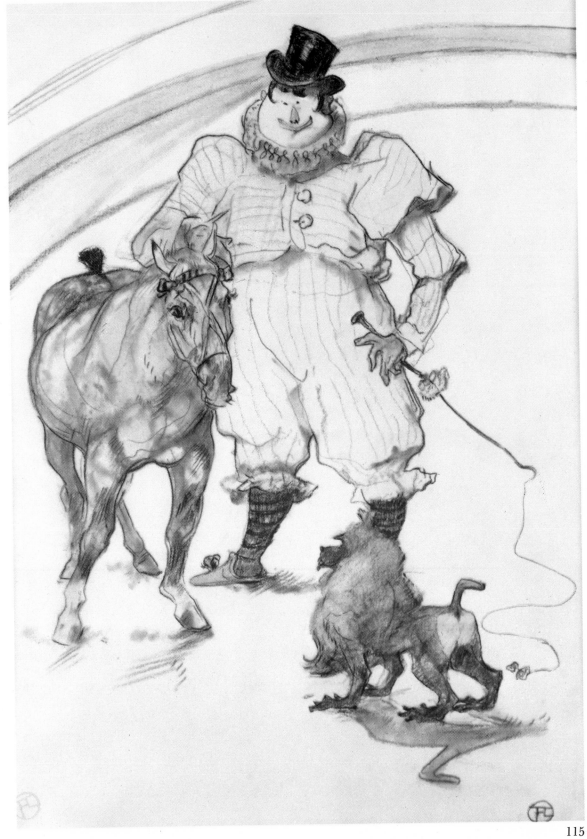

TOULOUSE-LAUTREC
At the Circus
Pencil and colored crayon
Chicago, The Art Institute

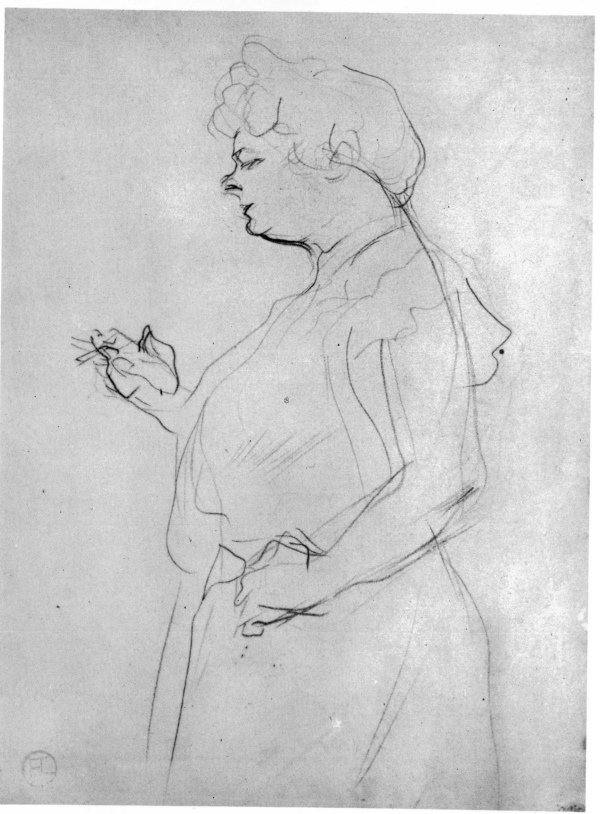

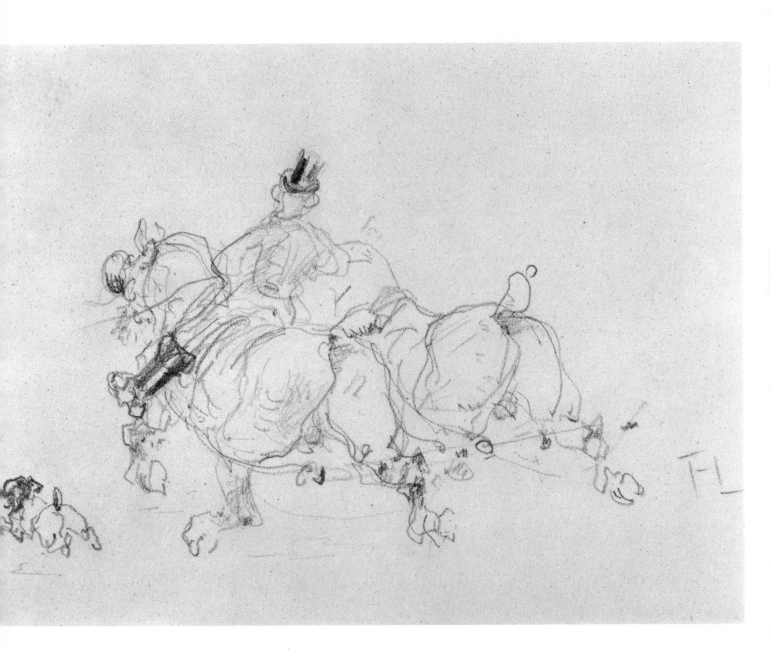

TOULOUSE-LAUTREC · *Pair of Horses with Postillion* · Black chalk · Ottawa, National Gallery of Canada

TOULOUSE-LAUTREC · *Mlle Lucie Bellanger* · Pencil on cream-colored paper · Vienna, Albertina

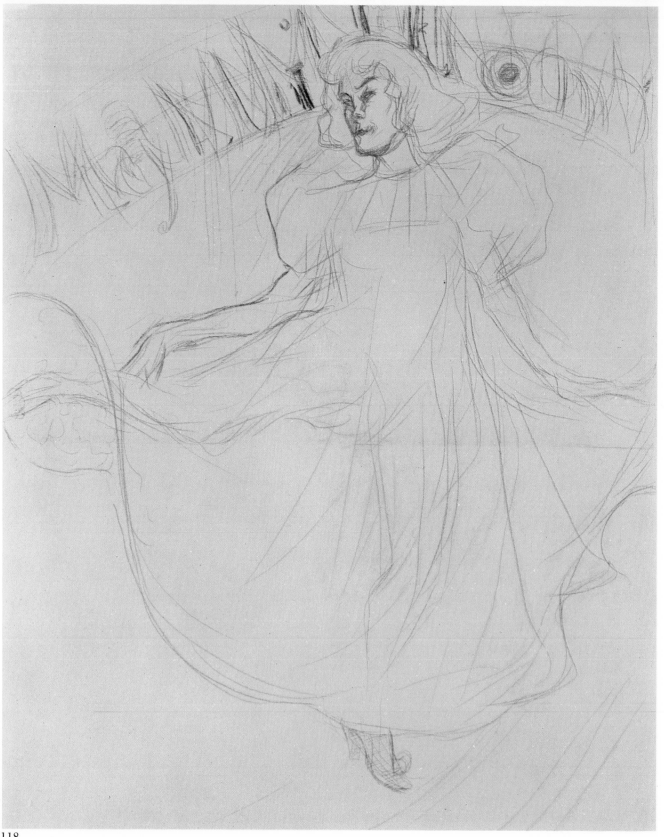

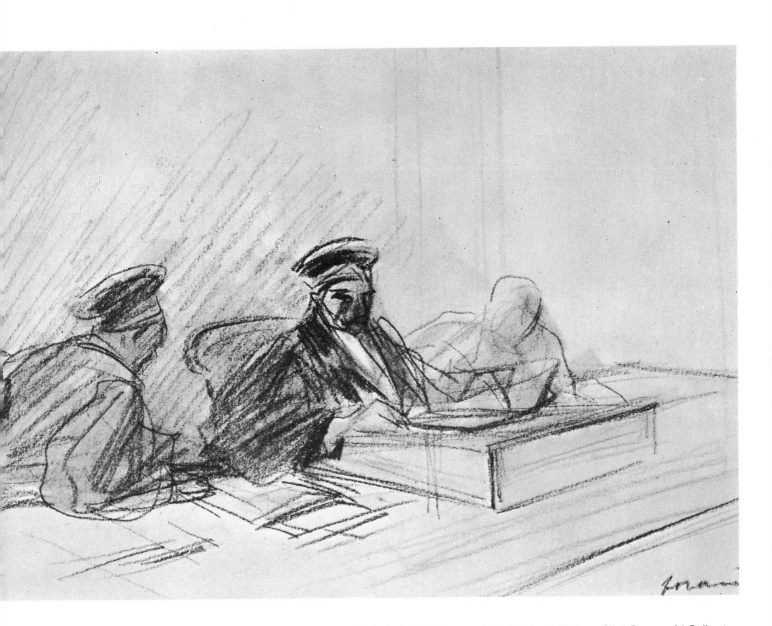

JEAN-LOUIS FORAIN · *The Judges* · Black chalk · Washington, D. C., National Gallery of Art, Rosenwald Collection

TOULOUSE-LAUTREC · Drawing for the Lithograph Poster of May Milton
Blue and black crayon on light-brown paper · New Haven, Yale University Art Gallery

EMILE-ANTOINE BOURDELLE · *Beethoven, 1900* · Black crayon · New York, Mr. and Mrs. Charles E. Slatkin

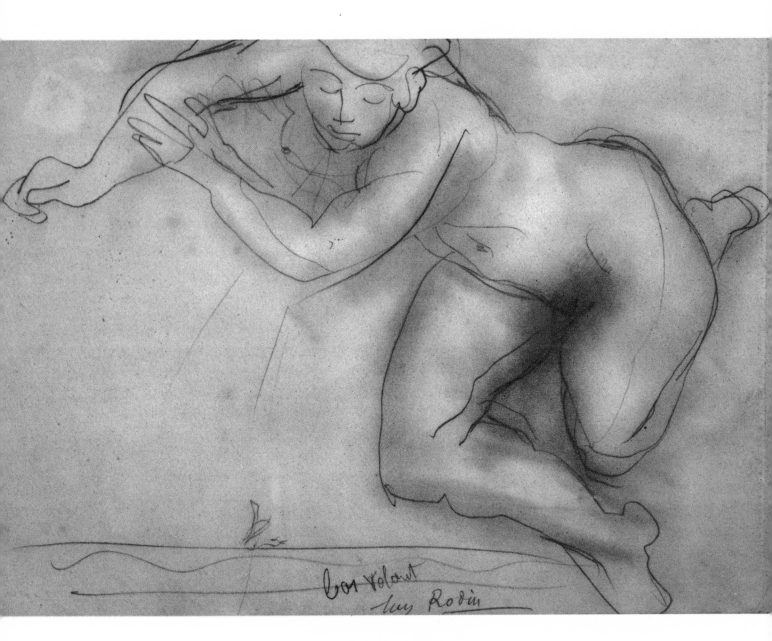

AUGUSTE RODIN • *Female Nude* • Pen and ink on tan paper • Paris, Jacques Mathey

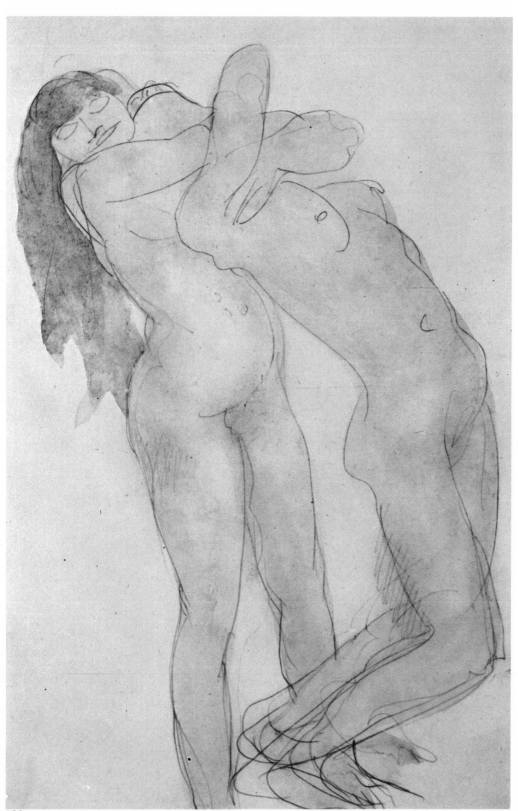

122

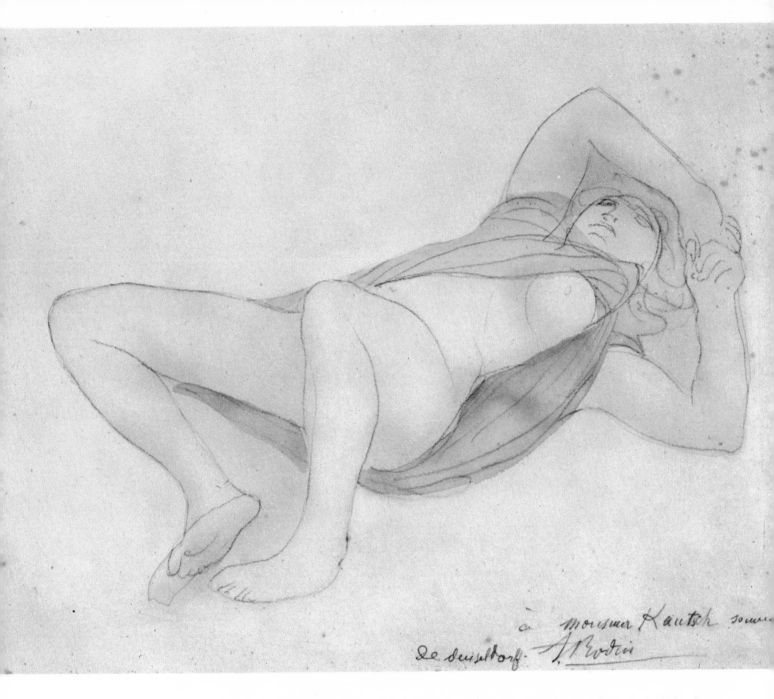

AUGUSTE RODIN · *Reclining Seminude Female* · Pencil and water color · New York, Walter Bareiss

AUGUSTE RODIN · *Two Nude Females* · Pencil and gray water-color wash on gray paper · Vienna, Albertina

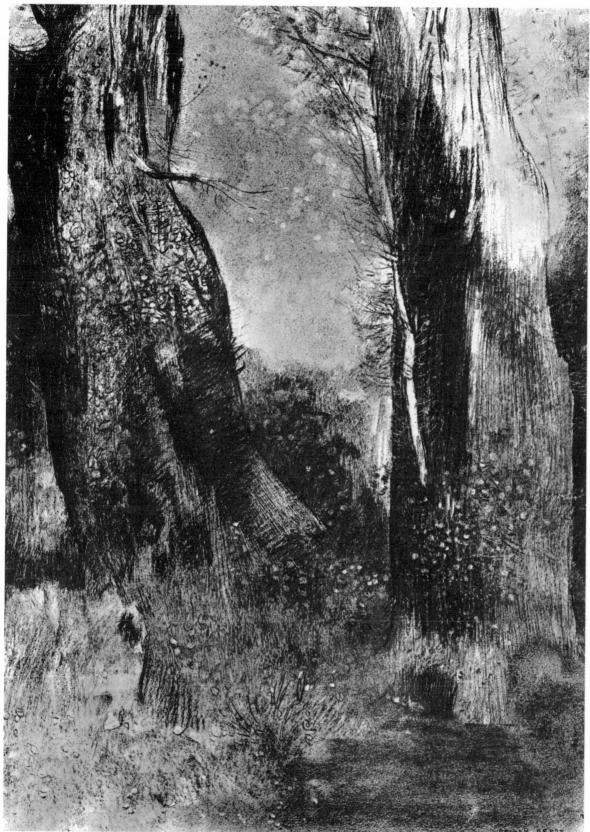

ODILON REDON
Tree Trunks in the Forest
Charcoal
Los Angeles
Mr. and Mrs. Norton Simon

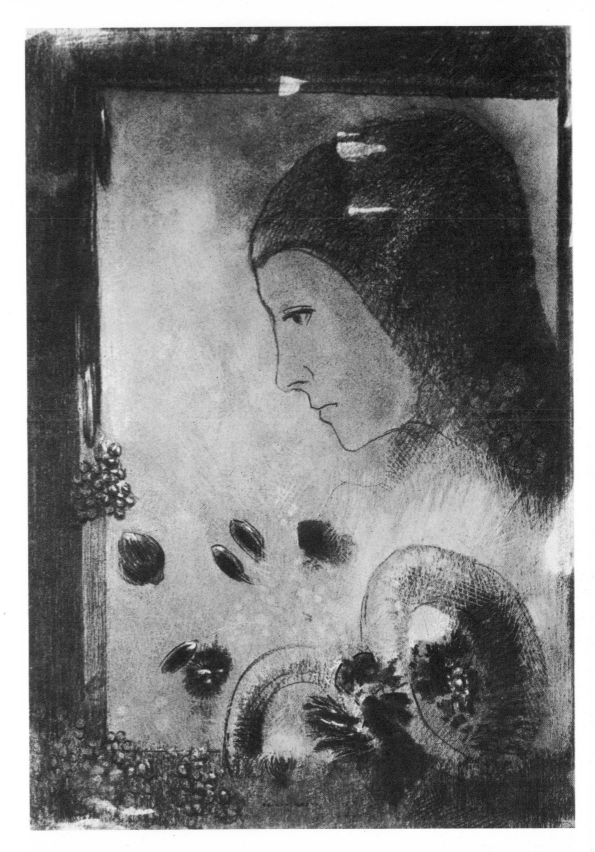

ODILON REDON
Woman's Profile and Flowers
Charcoal
Chicago, The Art Institute

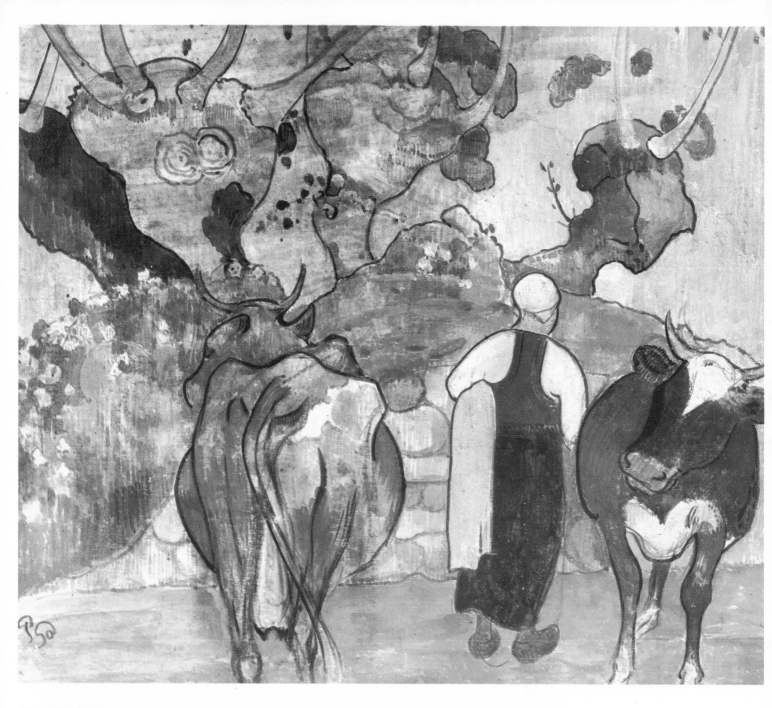

PAUL GAUGUIN · *Peasant Woman and Cattle* · Water color · New York, Mrs. Siegfried Kramarsky

PAUL GAUGUIN · *Head of a Peasant Girl* · Pencil, crayon, and wash · Cambridge, Mass., Fogg Art Museum

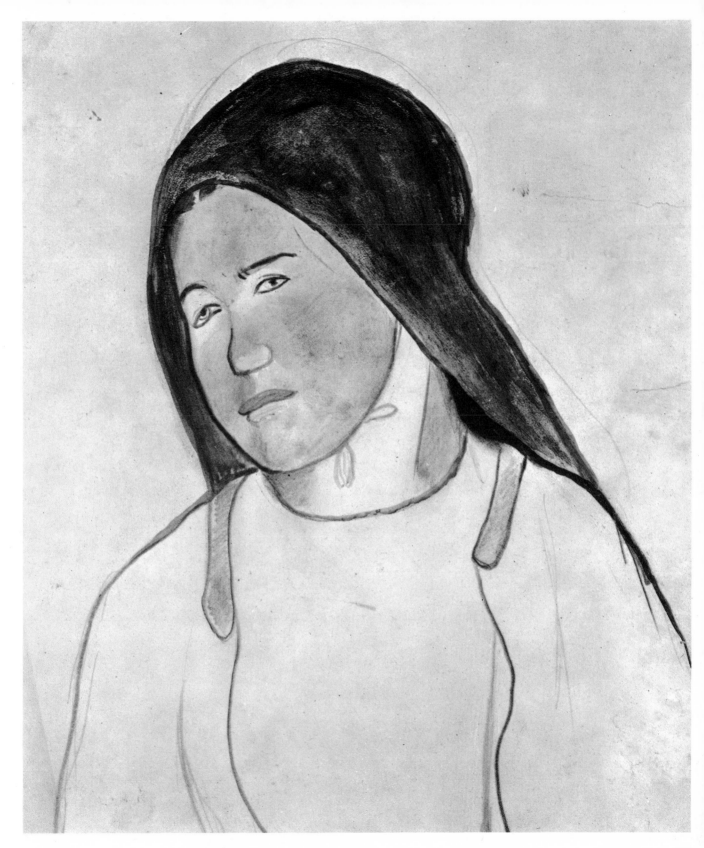

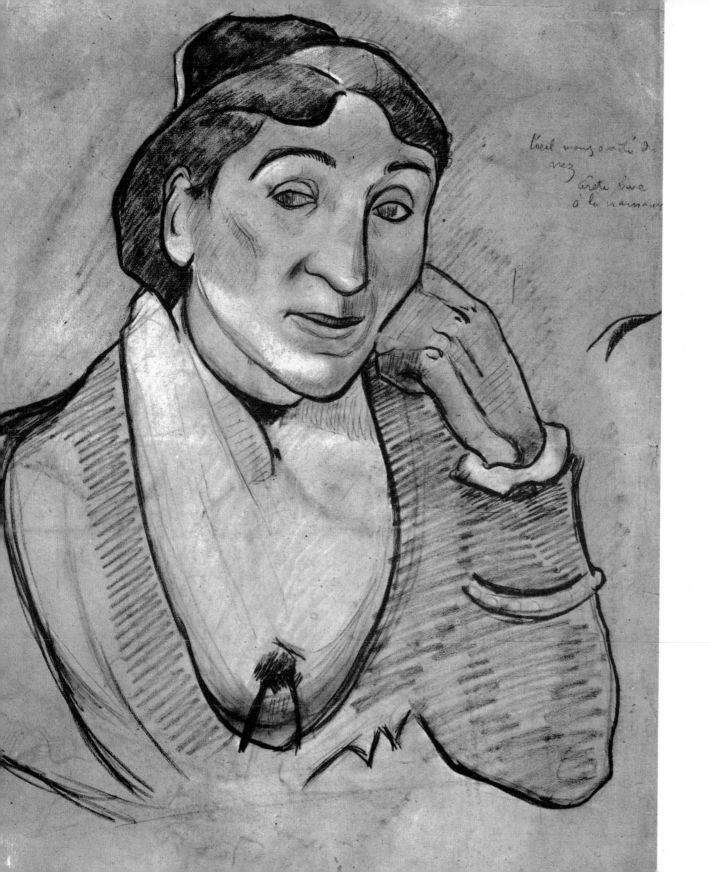

l'œil mange moitié d[...]
vez
arête vive
à la n[...]

PAUL GAUGUIN
L'Arlésienne
Charcoal on yellowish paper
Bradford, Pa., T. Edward Hanley

Biographies

BARYE, ANTOINE-LOUIS
Born in Paris 1796. Noted for his animal studies. Died in Paris 1875.

BAZILLE, JEAN FRÉDÉRIC
Born in Montpellier 1841. Pioneer Impressionist painter, considered a link between Courbet and the Impressionists. Died in Beaune-la-Rolande 1870.

BOUDIN, EUGÈNE
Born at Honfleur 1824. Went to Paris with a scholarship from the town of Havre and entered the Ecole des Beaux-Arts. Worked much in Trouville. Died at Deauville 1898.

BOURDELLE, ÉMILE-ANTOINE
Born in Montaubin 1861. Entered the Ecole des Beaux-Arts 1884, studied under Falguière. Worked briefly as assistant to Rodin, with whose theories of sculpture his were at variance. Died at Le Vesinet 1929.

CASSATT, MARY
Born in Allegheny City, Pennsylvania, 1845. Studied at the Philadelphia Academy of Fine Arts. Went abroad for further study 1868. Came into contact with Degas, Manet, Renoir, Cézanne, and other leaders of the Impressionist movement. Degas had the greatest influence on her work. Died in Mesnil-Beaufresne (Oise) 1927.

CÉZANNE, PAUL

Born at Aix-en-Provence 1839. Decided to become a painter in 1863. Frequented various art schools, where he met Impressionists—among them Monet, Courbet, and Bazille. Considered the father of modern art, his great influence began to operate after his death at Aix 1906.

COROT, JEAN-BAPTISTE CAMILLE

Born in Paris 1796. Did not follow his inclination toward art until he was 22. Became the pupil of Michallon and later of Victor Bertin, then studied in Italy. Corot worked in open air—early or late—to catch effects only to be seen at those times. Died in Paris 1875.

COURBET, GUSTAVE

Born at Ornans near Besançon 1819. In Paris in 1839 he became the leader of the Realist movement. In trouble because of his political activities, he took refuge in Switzerland 1873. Died at La Tour-de-Peiltz 1877.

DAUBIGNY, CHARLES FRANÇOIS

Born 1817 in Paris. Taught by his landscapist father. The most modern of the French Barbizon School. Notable for his direct influence on Impressionism through the young Monet. The only Barbizon painter to work outdoors. Near the end of his life he painted in Holland, as did many of the Impressionists. Died in Paris 1878.

DAUMIER, HONORÉ

Born at Marseilles 1808. Arrived in Paris with parents 1816. Studied drawing under Alexandre Lenoir. Made first political caricatures during 1830-32 period. Briefly imprisoned for caricature 1832. Worked for *La Caricature* and *Charivari* and painted without financial success. Died in poverty at Valmondois, nearly blind, 1879.

DEGAS, EDGAR

Born in Paris 1834. Began his studies in art at the Ecole des Beaux-Arts 1855 with Lamothe, a pupil of Ingres and Flaudrin. Studied the Florentine masters between 1856 and 1860. Feeling for composition and for spontaneous movement led him to the group of painters of the Café Guerbois and more particularly to Manet, whom he had met in the Louvre. Considered the greatest master of drawing of the second half of the nineteenth century. Died in Paris 1917.

DELACROIX, EUGÈNE

Born at Charenton-Saint Maurice 1798. Studied in the studio of Guérin and at the Louvre. Influenced by Gros and Géricault. Chief figure of the Romantic movement. Traveled in Morocco, Spain, Algiers, England, and the Netherlands. Died in Paris 1863.

FANTIN-LATOUR, HENRI

Born in Grenoble 1836. Painter and graphic artist, he was an outstanding independent. Although he associated with his *avant-garde* contemporaries, he was not influenced by them. Constantly studied the Old Masters. Died in Buré (Orne) 1904.

FORAIN, JEAN-LOUIS

Born at Rheims 1852. Entered the Ecole des Beaux-Arts 1867. Remained there short time, then entered atelier of Carpeaux. Made many drawings for magazines and publications. Died in Paris 1931.

GAUGUIN, PAUL

Born in Paris 1848. Began to devote all his time to painting in 1883. Especially influenced by the work of Pissarro. Later made friends with van Gogh. In the spring of 1887 embarked for Martinique. Worked there, Brittany, Arles, Tahiti, and in the Marquesas. Died in the Marquesas 1903.

JONGKIND, JOHAN BARTHOLD

Born at Latrop, Holland, 1819. Marine and landscape painter. Pupil of Isabey in Paris. The true master of Monet, Sisley, and Pissarro. Died in La Côte-Saint-André, near Grenoble 1891.

LUCE, MAXIMILIEN

Born in Paris 1858. A journalist for the Left, he was known as an anarchist and jailed after the notorious trial of The Thirty. Entered Neo-Impressionism through Signac's and Seurat's divisionism. Also influenced by the work of Pissarro. Died in Paris 1941.

MAILLOL, ARISTIDE JOSEPH BONAVENTURE

Born at Banyuls-sur-Mer 1861. At 21 won a scholarship to the Ecole des Beaux-Arts. Studied with Cabanel for 5 years. Contact with Gauguin aroused his interest in decorative problems. Worked in wax, clay, wood, and stone. Died in Paris 1944.

MANET, EDOUARD

Born in Paris 1832. Enrolled in the studio of Thomas Couture 1850. In 1863 his painting "Déjeuner sur l'Herbe" was exhibited at the Salon des Réfusés. The "Olympia" of 1865 also outraged the traditionalists, although Zola and Baudelaire hailed Manet as the originator of Naturalism. Formed the Impressionist School with Renoir, Monet, Sisley, Pissarro, Cézanne, and Degas. Died in Paris 1883.

MILLET, JEAN-FRANÇOIS

Born 1814 near Gruchy. Went to Cherbourg at 18 to study art. Later went to Paris with the help of the Municipal Council of Cherbourg. There joined the studio of Paul Delaroche. Influenced by Le Nain, Chardin, most of all by Poussin. Painted entirely from memory. Died in Barbizon 1875.

MONET, CLAUDE

Born in Paris 1840. Spent his youth in Le Havre. Returned to Paris 1857. Became friendly with Pissarro, Bazille, Renoir, and Sisley. Went to England 1870, then to Holland. His painting "Impression Sunrise" was exhibited in Paris 1874. This exhibit was the official baptism of Impressionism and Monet was recognized as the leader of the group. Died in Giverny 1926.

MORISOT, BERTHE

Born in Bourges 1841. In 1852 moved with her family to Paris. Began study with Corot 1861. Exhibited for the first time 1864. Manet helped her realize her métier. Exhibited with the Impressionists. Died in Paris 1895.

PISSARRO, CAMILLE

Born in Saint Thomas (West Indies) 1831. Became acquainted with Corot in 1855 and fell under his influence. Studied Turner in London during the War of 1870. With friend Monet, helped develop more fully the theories of Impressionism. Influenced Cézanne and Gauguin with color theories. Died in Paris 1903.

PUVIS DE CHAVANNES, PIERRE

Born in Lyons 1824. Studied briefly with Delacroix. Rejected by the Salons. Revolutionized mural painting, which now included landscape. Great influence as decorator. Died in Paris 1898.

REDON, ODILON

Born in Bordeaux 1840. Influenced by the botanist Armand Chavaud. Studied briefly under Gérôme in Paris. Found Impressionism too limited in scope: "While I recognized the necessity of this thing seen as a base, true art is in reality felt." Died in Paris 1916.

RENOIR, PIERRE-AUGUSTE

Born in Limoges 1841. Went to Paris 1844. Friendship with Bazille, Sisley, and Monet (whom he met in Gleyre's atelier) put him in touch with the Impressionists. Visited Algiers 1879 and Italy 1881. Settled in Provence 1906. Died in Cagnes 1919.

RODIN, AUGUSTE

Born in Paris 1840. Studied at Beauvais until 14. Returned to Paris. Made three vain atempts to enter the Ecole des Beaux-Arts. Studied with Barye. Revolted against official art. Rodin's drawings were mostly studies for the "Porte de l'Enfer," a project never completely realized. Died in Meudon 1917.

ROUSSEAU, THEODORE

Born in Paris 1812. An early visit to the Jura Forest decided Rousseau's vocation as a landscape painter. Studied landscape painting with La Berge near Paris. Refused repeatedly at the Salons. Retired to the Forest of Fontainebleau. Influenced by the work of Ruysdaël and Hobbema. Died at Barbizon 1867.

SEURAT, GEORGES

Born in Paris 1859. Entered the Ecole des Beaux-Arts 1878. Pupil of Lehmann, who had been a pupil of Ingres. Haunted the Louvre, where he studied the works of Delacroix. Unaware of the growing interest in Impressionism until he happened to read Ogden Rood's *Colour,* which led him to the theory of the division of light and its reaction upon surface textures. Died in Paris 1891.

SIGNAC, PAUL

Born in Paris 1863. Son of well-to-do parents, he began to paint at an early age. Became acquainted with the teachings of the Impressionists. Especially fond of van Gogh, Gauguin, and Cézanne. Developed with Pissarro and Seurat the theories and techniques of the so-called Neo-Impressionist School. Died in Paris 1935.

SISLEY, ALFRED

Born in Paris 1839. Impressionist interpreter of the Seine Valley and the Ile de France, he joined Monet, Renoir, and Bazille at Geyre's atelier. From 1885 more influenced by Monet than ever, he adopted Impressionist technique and colors. Died in Moret-sur-Loing 1899.

TOULOUSE-LAUTREC, HENRI MARIE RAYMOND de

Born at Albi 1864. First real teacher was Léon Bonnat, soon succeeded by Cormon. Later met Degas, through whom he found his true direction in art. Died in his mother's arms in the Château de Malromé 9 September 1901.

VALLOTTON, FELIX EDOUARD

Born in Lausanne 1865. A woodcut specialist, he produced decorative art, posters, and lithography. Tried pointillism, exhibited at the Salon des Indépendants. Worked for the *Revue Blanche, Le Rire,* and *Le Courier Français.* Died in Paris 1925.

VAN GOGH, VINCENT

Born at Groot Zundert, Holland, 1853. Became apprentice at Goupil's in The Hague, was later at Goupil's in London. Settled in Paris May 1875. Painted in Arles. Entered Asylum St. Paul at St.-Rémy-en-Provence. In 1890 moved to Auvers-sur-Oise. Attempted to end his life 27 July 1890. Died 29 July 1890.

Bibliography

GENERAL

Chassé, C. *Le Mouvement Symboliste.* Paris, 1947. (Chapter on Rodin, pp. 183-95.)

Duret, T. *Manet and the French Impressionists.* London, 1910.

Gobin, M. *L'Art expressif au XIXe siècle français.* Paris, 1960.

Huyghe, R. and P. Jaccottet. *Le Dessin français au XIXe siècle.* Lausanne, 1948.

Loevgren, S. *The Genesis of Modernism: Seurat, Gauguin, Van Gogh and French Symbolism in the 1880's.* Stockholm, 1959.

Rewald, J. *The History of Impressionism.* New York, 1946.

Wechsler, J. *French Impressionists and Their Circle.* New York, 1953.

CASSATT

Breeskin, A. *The Graphic Work of Mary Cassatt.* New York, 1948.

Watson, F. *Mary Cassatt.* New York, 1932.

CÉZANNE

Berthold, G. *Cézanne und die alten Meister.* Stuttgart, 1958.

Fry, R. *Cézanne: A Study of His Development* (2d ed.). London, 1932.

Loran, E. *Cézanne's Compositions.* Berkeley, 1943.

Rewald, J. *Paul Cézanne, Carnets de Dessins* (2 vols.). Paris, 1951.

COROT

Sérullaz, M. *Corot.* Paris, 1951.

DAUMIER

Adhémar, J. *Honoré Daumier, Drawings and Watercolors.* New York and Basel, 1954.

Adhémar, J. and C. Roger-Marx. *Daumier, Dessins et Aquarelles.* Basel, 1954.

Maison, K. *Daumier Drawings.* New York and London, 1960.

DEGAS

Cooper, D. *Pastelle von Edgar Degas.* Basel, 1952.

DELACROIX

Jenneau, G. *Le Dessin de Delacroix.* Paris, n.d.

Lassaigne, J. *Eugène Delacroix.* New York, 1950.

Price, V. *The Drawings of Delacroix.* Los Angeles, 1961.

GAUGUIN

Goldwater, R. *Paul Gauguin.* New York, 1957.

Leymarie, J. *Paul Gauguin.* Basel, 1960.

Rewald, J. *Gauguin Drawings.* Paris, 1958.

LAUTREC

Focillon, H. and E. Julien. *Dessins de Toulouse-Lautrec.* Geneva, 1959.

Mack, G. *Toulouse-Lautrec.* New York, 1938.

MANET

Leiris, A. de. *The Drawings of Edouard Manet.* Cambridge, Mass., 1957.

MILLET

Soullié, L. *Jean-François Millet.* Paris, 1900.

MONET

Rouart, D. *Claude Monet.* Geneva, 1958.

Seitz, W. *Claude Monet.* New York, 1960.

MORISOT

Mongan, E. *Berthe Morisot.* New York, 1960.

PISSARRO

Rewald, J. (ed.) *Camille Pissarro, Letters to his Son Lucien.* New York, 1943.

REDON

Mellerio, A. *Odilon Redon.* Paris, 1923.

RENOIR

Bosman, A. *Pierre-Auguste Renoir.* London, 1961.

Daulte, F. *Pierre-Auguste Renoir, Aquarelles, pastels et dessins en couleurs.* Basel, 1958.

Fosca, F. *Renoir.* Paris, 1961.

RODIN

Fresch, V. and J. T. Shipley, *Auguste Rodin.* New York, 1939.

Mauclair, C. *Auguste Rodin.* London, 1909.

SEURAT

Seligman, G. *The Drawings of Georges Seurat.* New York, 1947.

VAN GOGH

Cooper, D. *Van Gogh, Drawings and Watercolors.* New York and Basel, 1955.

Huyghe, R. *Les dessins de Van Gogh.* Paris, 1936.

Van Gogh, V. *Vincent Van Gogh, Letters to Emile Bernard* (ed. and trans. by D. Lord). New York, 1938.

Van Gogh, V. *The Complete Letters of Vincent Van Gogh.* (3 vols.). New York, 1958.